The Divine Presence

Asian Sculptures from the
Collection of Mr. and Mrs. Harry Lenart

By Pratapaditya Pal

Library of Congress
Cataloging in Publication Data

Pal, Pratapaditya.
 The divine presence.

Catalog of an exhibition held at the Los
Angeles County Museum of Art, Aug. 15-Oct. 15, 1978.
 Bibliography: p.
 1. Sculpture, South Asian—Exhibitions.
2. Sculpture, Southeast Asian—Exhibitions.
3. Gods in art—Exhibitions. 4. Lenart, Harry—
Art collections—Exhibitions. I. Los Angeles Co.,
Calif. Museum of Art, Los Angeles. II. Title.
NB1000.P33 732'.4'074019494 78-59792
ISBN 0-87587-086-4

Published by the
Los Angeles County Museum of Art
5905 Wilshire Boulevard
Los Angeles, California 90036

Designed in Los Angeles by
Alan Lugena

Text set in Palatino by
Typographic Service Co., Los Angeles

Printed in an edition of
6,100 by Anderson Lithograph Co.,
Los Angeles

Exhibition Itinerary

Los Angeles County Museum of Art

University Art Gallery
 University of Texas at Austin

The Fine Arts Galleries
 University of Wisconsin, Milwaukee

Utah Museum of Fine Arts,
 The University of Utah, Salt Lake City

University of Iowa Museum of Art
 Iowa City

Portland Art Museum
 Portland, Oregon

Cover: **37. Buddha Śākyamuni**

Contents

Preface

The sculptures in this exhibition are selected from a collection assembled by Mr. and Mrs. Harry Lenart during the last fifteen years. Many different motives impel a person to become a collector, but for the Lenarts the principal incentive here has been to supplement the holdings of public institutions. The people of Los Angeles are indeed fortunate that Mr. Lenart, who is originally from New York, decided some twenty-five years ago to settle here and that subsequently he became a patron and trustee of the County Museum of Art. Of the forty-one sculptures included in this exhibition, one belongs to the Museum of Cultural History, UCLA (no. 21), those listed with acquisition numbers have already been given to this Museum, and the remaining will become part of the Museum's permanent collection over the next few years. We are particularly grateful to the Lenarts for agreeing to lend the objects now and for allowing them to travel to various institutions around the country. This is part of an ongoing program of the Indian and Islamic department to make small exhibitions available to institutions, particularly university museums, that have little or no oriental art.

I met Harry and Yvonne Lenart in 1970, soon after I joined the Museum as the curator of the newly formed department of Indian Art. The Lenarts were already collecting Indian sculpture with the advice of Professor and Mrs. Leroy Davidson of UCLA. In fact, it was at the Davidsons' home that the Lenarts learned to appreciate Indian sculpture in the early 1960s when India was very much in the forefront of the counter-culture movement in this country. The Lenarts had already been collecting European Old Master drawings and contemporary art for several decades, but their first encounter with Indian art soon developed into a permanent love affair.

Mr. Lenart's career has been as varied as his taste in collecting is eclectic. A member of the New York Stock Exchange, he was once a young gentleman farmer in New York State; he has raised quarter horses and was a breeder of prize-winning cocker spaniels in Scottsdale, Arizona, where subsequently he became involved in urban development; for some years he owned the Sans Souci hotel in Jamaica; and he was also a film producer in Hollywood. But nothing has given him as much satisfaction as his

sponsorship, in the late Thirties and early Forties, of countless European refugees for whom he provided employment by starting a ceramic factory in New York. His concern for civic and humanitarian affairs has continued all his life, and in Los Angeles, apart from the Museum, he has been closely associated with UCLA, various hospitals, and several other charitable and cultural organizations.

Although their love for Indian art germinated in the Davidsons' Bel Air home, Yvonne Lenart's association with India goes back at least a generation. Her father was in Delhi for two years in the early part of this century and was involved in designing the great Delhi Durbar in connection with the visit to India of King George V of Britain. Born in Canada, Yvonne Lenart has lived most of her life in Los Angeles and has been closely associated with the UCLA Art Council and the Museum Costume Council. For some time she was the chairman of the Costume Council's Acquisitions Committee.

In 1975 Mr. Lenart was elected to the Board of Trustees of the Museum. Prior to that time he had simply bought sculptures that he liked. But upon joining the Board he decided that it would be more appropriate for him to buy in areas related to the Museum's already strong and internationally acclaimed Indian collection. As a curator I was then desperately searching for an angel who would help me build up a small collection of Southeast Asian sculptures to complement our Indian collection. The timing could not have been more propitious; Mr. Lenart simply instructed me to find the best Southeast Asian sculptures available, and when I did, he bought them. Consequently about a third of the sculptures in this exhibition are from Cambodia, Thailand, and Indonesia, and these constitute a very handsome nucleus for a distinguished collection of Southeast Asian sculpture.

All exhibitions are collective efforts in which many individuals contribute their own very special talents to make it a success. Members of the conservation, photographic, exhibitions and publications, registrar, preparation, security, shipping, and custodial departments of the Museum have been involved in this project. To name them all would be impossible, but

to thank them is a pleasure. However, I would like to mention my colleagues Cathy Glynn and Ginni Dofflemyer for their ungrudging help and Martha Brack for preparing the manuscript. Thanks are also due to the authorities of the Museum of Cultural History, UCLA for agreeing to lend no. 21. Finally, I am particularly happy that Ann Koepfli, who is a friend of both the Lenarts and me, edited this catalog.

P.P.

The rich
will make temples for Siva.
What shall I,
a poor man,
do?
My legs are pillars,
the body the shrine,
the head a cupola
of gold.
Listen, O lord of the meeting
 rivers,
things standing shall fall,
but the moving ever shall stay.[1]

<div align="right">Basavanna (1106–67)</div>

Introduction

The sculptures in the Lenart Collection are from the Indian subcontinent and from Southeast Asia, specifically Indonesia, Thailand, and Cambodia. Irrespective of stylistic or iconographic differences, they were all created for one purpose: to express in tangible form the divine presence. Furthermore, they all depict gods and goddesses of Indian origin, and hence the basic forms also reflect Indian aesthetic norms. However, the styles of the sculptures from Southeast Asia are recognizably different than those from India itself and at times, the themes, too, appear to be distinctly local (see no. 33); it is clear that certain images fulfill specific religious needs in specific areas.

The gods and goddesses, deified teachers, or saints represented in all the sculptures belong to the three principal religions of the area: Hinduism, Buddhism, and Jinaism. Oldest of the three, Hinduism is a collective term covering three major religious systems and countless minor sects. The three major religions are known as Vishnuism or Vaishnava, Sivaism or Saiva, and Saktism or Sakta, named for the principal deities Vishnu, Siva, and Sakti respectively. Of these, Vishnu and Siva are male and are two different aspects of a supreme being known as Brahman. Although regarded as an abstract concept, Brahman is said to assume three different forms in theistic Hinduism: Brahma, the creator; Vishnu, the preserver; and Siva, the destroyer. Of the three, Brahma has remained simply a figurehead, while Siva and Vishnu are the two leading gods of the Hindu pantheon. Both Siva and Vishnu have innumerable emanations and manifestations, each with its distinct iconography. Furthermore, over the millennia countless myths have been invented by the brahman priests and mythographers, and these, along with the images, have provided the artists with an incredibly rich repertoire.

The Saktas believe that the supreme being manifests itself in the form of the Great Goddess who is the embodiment of all cosmic energy (sakti). The concept of sakti plays a fundamental role in theistic Hinduism, and in one form or another the goddess is an intimate part of Vishnuism and Sivaism as well as the principal deity of Saktism. Furthermore, whether followers of Vishnu or of Siva, most Hindus also worship Srī-Lakshmī, the goddess of wealth and prosperity. Similarly, the goddess Shashthī is universally supplicated for progeny and the welfare of children. And one has only to glance at the medieval Indian temple to see the pervasive use of the female form, whether it be celestial or mortal. Even the pantheons of Buddhism and Jinaism (also called Jainism), both of which began as monastic religious systems, ultimately were seduced by the concept of the Magna Mater to include specially created goddesses of their own or those adopted from more ancient religions.

An attempt to discuss briefly the religious and philosophical world of the Hindu in an essay such as this would be to try to compress an ocean into a lake. However, the following comments by Zimmer regarding the inseparable relationship between Hindu art and religion are worth repeating:

> Hindu sculpture is one of the most magnificent chapters in the whole history both of the world's art and of the world's religion—for in Indian civilization there was never a division or fundamental contradiction between art and religion, or between art, religion, and philosophic thought. Inherited revelation, the scholastic traditions of the priesthoods, and the popular beliefs worked upon each other by ever renewed processes of influence and were pervaded meanwhile by philosophical ideas originating in ascetic experiences, yogic exercises, and introverted intuition. The luxuriant display of religious sculpture so characteristic of the great temples of pilgrimage is therefore a readily legible pictorial script that conveys through an elaborate yet generally understood symbolism, not only the legends of popular cult, but simultaneously the profoundest teachings of Indian mataphysics.[2]

While Hinduism claims to have no beginnings, Buddhism and Jinaism were originated by two remarkable men who were contemporaries during the sixth and fifth centuries B.C. Neither Buddha Śākyamuni (nos. 32-38) nor Mahāvīra, regarded as the founders of Buddhism and Jinaism respectively, were brahmans; on the contrary, they were kshatriya (warrior caste) princes, who renounced luxurious lives in order to find salvation from the chain of

rebirth. Both lived and preached in the eastern part of the sub-continent and both rebelled against the ritual-dominated religion of the brahman priests. While the Buddha did not deny the existence of gods, he did not encourage their worship; and Mahāvīra, on the other hand, was certainly an atheist. Both advocated simple and clean living and the renunciation of all material wealth, but the Buddha favored the communal, monastic life, whereas Mahāvīra preferred asceticism. It may be pointed out that like Christ, Buddha and Jina are titles rather than personal names. The word Buddha signifies ''the enlightened'' and Jina means ''the conqueror.'' Over the centuries, both religions became theistic and evolved elaborate pantheons and rituals of their own, which are not unlike the Hindu deities and modes of worship. Although the Jainas generally worship only the twenty-four Jinas or Tīrthaṁkaras, as they are alternatively called, of which Mahāvīra is the twenty-fourth, the sculptural program of a medieval Jaina temple is just as rich as that of a Hindu temple. Few Buddhist temples in India have survived, but the gods of later Buddhism, both Mahayana and Vajrayana, are far more numerous than those of the Jainas and are often conceptually and iconographically related to the Hindu divinities.

Divine images, whether Hindu, Buddhist, or Jaina, are based upon certain fundamental aesthetic and conceptual assumptions that are shared by all religious systems. All gods and goddesses carry specific attributes or are associated with animal symbols drawn from a common pool. For example, the bull is Siva's mount (no. 12) and Vishnu rides the mythical bird Garuḍa (no. 3); the Buddha in Thailand is mounted on a Garuḍa-like creature (no. 33), and a Jina has a hawk (no. 40). The attributes or emblems which they carry are usually flowers or weapons. The lotus, for instance, is a ubiquitous symbol, and is held by Vishnu, Siva, Umā, and Lakshmī of the Hindu pantheon, as well as by Avalokiteśvara and Tārā of the Buddhists and by several Jaina divinities. The auspicious śrīvatsa mark is delineated, usually as a diamond, on the chests of Vishnu as well as of the Tīrthaṁkaras. And although historical personages, such as Buddha and Mahāvīra, are not generally provided with multiple arms, most other divinities have additional limbs symbolic of the gods' superhuman powers and cosmic nature.

Animism and nature worship, two aspects of primitive Indian religious life, have survived to the present day and their practice may still be witnessed in village and tribal India. The animal that is most widely associated with the iconography of all religious systems is the snake or nāga. The serpent is worn by Siva and Gaṇeśa as an ornament (nos. 17, 28); it serves as a couch for Vishnu (no. 2) when he sleeps in the cosmic ocean; it is both a seat and a canopy for Buddha Śākyamuni (no. 35) and for at least two Tīrthaṁkaras (no. 41). A serpent also sheltered the baby Krishna at his birth and was later destroyed by the divine child in the story of Kāliyadamana. The snake is a formidable creature in a tropical world, and it is easy to see why the Indian mind should have been fascinated as well as threatened by it; and fear leads easily to veneration.

The association of animals with divine images can be understood on many levels. In addition to serving as his mount, Garuḍa is also a distinguishing attribute of Vishnu, just as the lion identifies St. Mark in medieval Christian iconography. However, animals play an even more important role in Indian thought and art. The remarkable empathy for animals and plants in India is engendered by the belief that in the process of transmigration or rebirth one can just as easily be reborn an animal or a plant as a human being. More specifically, most animals associated with the divinities also have symbolic meanings. Thus, Siva's bull symbolizes the divine *dharma*, a word difficult to translate but which may here imply divine order or religion. Or again, Vishnu's Garuḍa is said to signify the mind that is present in all rational beings.

A symbol, however, can be interpreted in many different ways as is the case with the serpent couch of Vishnu. The serpent is known as *Ananta* (endless, infinite) and as *Śesha* (end, residue). Thus, one can state that ''the serpent itself relates the fact that God is the whole and the end of the Universe'' as Dasgupta has explained, and that its multiple hoods suggest ''the world of infinitude expressed in the multifold ways of the finite.''[3] Or, as Zimmer has pointed out, ''the animal and the human aspects...are

dual manifestations of a single divine presence, which, by and in itself, is beyond the forms it assumes at will when bringing the world-process into play. The anthropomorphic apparition through which it is made manifest to human devotees is in essence identical with the reptile and this, in turn, with the timeless element of the cosmic sea."[4]

In a similar fashion trees, plants, and flowers are a constant presence in the divine image. At a relatively unsophisticated level, the tree is regarded as the habitat of ghosts, goblins, spirits, and demigods of all kinds who are appeased and propitiated by the offerings made to the tree. On another level, the tree or plant is a visible symbol of fertility; it is synonymous with life and hence is to be nurtured and loved, and by extension, adored. On a more metaphysical level, the tree symbolizes the cosmic pillar that stretches from the earth to the sky and supports the universe. The significance of the tree is evident from the fact that even in the presence of an image the actual worship is offered to a pot of water containing a plant known as *purṇaghaṭa* which is also carried by the river goddess Yamunā (see no. 18). Furthermore, the entire ritual of the installation of an image begins with a bathing ceremony using a decoction made from leaves and twigs of given auspicious trees.

In the delightful representation of the celestial nymph from Khajuraho (no. 24), the tree above her head announces that both are symbols of fertility. The same function is often served by the fruit or flower held by a deity. In the scene of the conversation between Nara and Nārāyaṇa (no. 1), a solitary tree is regarded as sufficient to symbolize the forest hermitage, whereas the arbor below which Krishna flutes (no. 4) is the divine wish-fulfilling tree (*kalpavṛiksha*). Buddha Śākyamuni gained enlightenment by meditating under a tree which now signifies knowledge or wisdom and hence is known as the Bodhi tree. Every Jina is associated with one tree or another (no. 39), and every devout Vaishnava has a basil plant (*tulasī*) in his house. To worship the basil is to worship Vishnu himself. Indeed, the importance of the tree in Indian religious thought is evident from a passage in the *Taitirīya Brāhmaṇa* (III, 8, 9, 6): "Brahma is the wood, is the tree."

In addition to their symbolic role, trees and plants are intimately associated with the sculptural form by means of analogy. In describing the beauty of the ideal form, Indian poets and aesthetes always compare the limbs with similar forms in nature. Thus, the ideal male is compared with the stately and noble *sāla* tree (*śālaprāṁśu*) or with the *nyāgrodha*, the Sal or *Vatica Robusta* and the *Ficus Indica* respectively; the ideal woman is compared to the *nyāgrodha* or to the vine. Eyes are said to imitate the lotus bud, fingers are like bean pods, and thighs like the trunk of a banana tree. To cite only one instance, while describing the goddess Pārvatī in his *Kumārasambhava* the fifth-century poet Kālidāsa says: "How can I describe the warmth and smoothness of her thighs which are as supple but not as rough as the elephant's trunk nor as cold and uninviting as the banana stem?" And finally, he concludes that the creator gathered together the essence of all nature and thereby created the beautiful form of Pārvatī.

The images assembled here served one of two purposes: either they were worshiped directly as icons in a public or private shrine, or they played a didactic role as part of the overall sculptural program of a temple. Most of the sculptures belong to the latter category and their forms were often determined by their physical situation in the architectural context. Thus, the celestial nymphs (nos. 24, 25) probably adorned columns on a temple wall, while the relief representing a cow licking a Sivaliṅga (no. 9) perhaps served as a tympanum. The mukhaliṅga (no. 8) was enshrined as an image in a temple, and some of the bronzes were once objects of adoration in domestic shrines, i.e., the Lakshmī-Nārāyaṇa (no. 3), whose effaced condition was caused by constant pouring of ritual unguents over the image. Generally, Hindu worship involves bathing an image daily with consecrated water, milk, and clarified butter. This concoction, symbolic of the nectar that flows from the feet of the god (*charaṇāmṛita*), is collected by means of the spout (see no. 13) and reverently drunk by a devotee. In fact, the pious Hindu regards his image as a living entity that must be bathed, fed, entertained, and put away to sleep every night, just as one would treat a child. Before it is worshiped, each icon is infused with life by the ceremony known as *prāṇapratishṭhā*,

whereby the deity is invoked and brought to reside in the image—this despite the fact that the Indian philosophers tell us that the image is only a tangible symbol and that reality is formless.

Commissioning a temple or an image was considered the highest act of piety, one that not only fulfilled all desires in this life, but also assured final release from the chain of rebirth. Thus, the unknown author begins the section on images in the *Matsyapurāṇa*, one of the oldest scriptures, with the following statement: "I shall explain to you the Karma-Yoga of Divine worship and reciting the name of God for there is nothing like it in the three realms to bestow enjoyments and mukti (freedom)."[5] And this Karma-Yoga, which severs the bondage to this world, is said to consist of the installation of divine images and their worship. Elsewhere we are told how one can benefit from images made of different materials.
Thus, Varāhamihira (sixth century A.D.) tells us that:

> Images made of wood or clay bring (to their worshipers) long life, fortune, strength, and victory; those made of jewels are for the good of the people, and the golden ones bring prosperity. Images made of silver bring fame, while those made of copper cause increase of population...[6]

Most religious texts dealing with aesthetics declare that if the image does not conform with the prescribed rules it is not worthy of worship. Among these rules the most cardinal is that relating to proportions. Theories of proportions (*tāla-māna*) are given in great detail in most important aesthetic manuals, but a thorough examination of such theories with reference to actual images is still to be undertaken. And yet, for stylistic analysis, such a study would be of fundamental importance in determining how far differences in canons of proportions influence stylistic variations. In stressing the almost universal importance of the theory of human proportions as a reflection of the history of styles, Panofsky remarked:

> Not only is it important to know whether particular artists or periods of art did or did not tend to adhere to a system of proportions, but the how

of their mode of treatment is of real significance. For it would be a mistake to assume that theories of proportions *per se* are constantly one and the same.[7]

Indeed, there are significant differences in the various theories of proportions found in Indian texts on aesthetics, and perhaps these differences partly account for the stylistic variations in different regions and ages. For example, in northern Indian texts it is generally specified that the height and breadth of the face should be equal, and so we find that the faces are usually round in figures from that area. South Indian texts, on the other hand, recommend that the height of the face should always be greater than the breadth, and this automatically results in the more elongated facial type that is characteristic of South Indian images. It is interesting to note that the relatively early texts on the theory of proportions divide the length of the figure into fractions, the lowest fraction being used as the basic unit with which the proportions of the other limbs are worked out. This is quite different from the later system of the *tāla*, whereby the modulus is the length of the face and accordingly the figure is *daśatāla* (ten face lengths), *navatāla* (nine face lengths), etc. While the earlier system is more akin to that used by the Greeks (in that the total dimension was not a multiple of a constant modulus, but rather the common fraction of a larger quantity was the measure of the basic unit), the latter is far closer to the theory of proportions adopted and favored by Byzantine artists.[8]

The Indian artist is constantly reminded that to be beautiful images must conform to prescribed lineaments and proportions. "There are some to whom that which captivates their heart is lovely. But for those who know, that which falls short of canonical proportion is not beautiful."[9] How amazingly close this remark is to the Greek insistence on the theory of proportions as a criterion for aesthetic evaluation. Galen informs us that "Chrysippus holds that beauty does not consist in elements but in the harmonious proportions of the part...of all parts to all others, as it is written in the canon of Polyclitus."[10]

In admiring these sculptures in a museum today, we are likely to forget that in their original context they were part of the beholder's spiritual rather than

aesthetic experience. The image is not only an external and visible support for meditation, but a "religious universe" that must be entered and assimilated. This is a complex process and begins with the elementary act of visualizing the divinity. Thereafter, the devotee must identify with the divinity represented—a task far more difficult than visualization. As we are told, "one cannot venerate a god unless one is a god oneself" (*nadevo devam archayet*). However, it should be pointed out that this process of identification with the image is a large part of the artist's aesthetic experience as well. The texts emphasize that "the painter's own shape comes out in the picture" (*lekhakasya cha yad rūpaṁ chitre bhavati tad rūpyāṇ*). In this sense, like the ideal devotee, the ideal artist is a yogi as well; the former is involved with the yoga of meditation (*dhyānayoga*), the latter with the yoga of both meditation and action (*karmayoga*).

No concept is so fundamentally Indian as that of yoga. Literally the word means "to yoke," "to harness," or "to bind together" and generally it serves to "designate any *ascetic technique* or any *method of meditation*."[11] It is a means whereby one attains pure being and gains liberation from the chain of rebirth. We have already stressed the importance of the image in the process of meditation, but it is interesting to note that the divine image itself may be a representation of an ideal yogi or yoginī. Not only are the gods and goddesses often represented in postures and gestures associated with yoga, but their smooth, flawless bodies radiate the "kinetic energy" which can only be harnessed by yoga. It is not a body that depicts nervous tension or expresses animal vitality or fugitive emotions. As Kramrisch has pointed out:

It is not scientific in the sense of observation and description in its structure, but it is suggestive of the vital currents that percolate the entire living frame....The muscular substance seems to melt away while it is being sustained and transmuted....It is wrapped all round the bones that are not visible, so that all joints appear as passages of a ceaseless and consistent movement. The transubstantiation of the body is made visible by the transformation of the plastic means.[12]

In the ultimate analysis neither style nor iconography is as significant as the attitude of *bhakti*, or the abject devotion of the pious worshiper, for that is what makes the symbol a potent spiritual presence. *Bhakti*, which means more than devotion and implies a total selfless surrender to the deity of one's choice, is not only the most distinctive element in the Indian mode of worship, but also colors the inner eye with which the devotee sees the Ultimate Reality beyond the tangible object of worship. As Krishna instructs Arjuna in the *Bhagavad Gītā*:

God dwells in the heart of all beings, Arjuna; thy God dwells in thy heart. And his power of wonder moves all things—puppets in a play of shadows—whirling them onwards on the stream of time. Go to him for thy salvation with all thy soul, victorious man. By his grace thou shalt obtain the peace supreme, thy home of Eternity.[13]

Notes

1. J. B. Alphonso-Karkala (ed.), *An Anthology of Indian Literature*, Harmondsworth, 1971, p. 494.

2. H. Zimmer, *The Art of Indian Asia*, I, New York, 2nd ed., 1964, p. 12.

3. S. N. Dasqupta, *Fundamentals of Indian Art*, Bombay, 1953, pp. 39-40.

4. Zimmer, op. cit., p. 13.

5. A Taluqdar of Oudh, (tr.), *The Matsya Puranam*, II, Allahabad, 1916, p. 302.

6. J. N. Banerjea, *The Development of Hindu Iconography*, 2nd ed., Calcutta, 1956, p. 565.

7. E. Panofsky, *Meaning in the Visual Arts*, New York, 1955, p. 55.

8. In the opinion of Panofsky (ibid., pp. 76-77) the Byzantine practice of measuring the "dimensions of the body by one fairly large unit or module" was probably borrowed from the writings of the "Brethren of Purity," an Arabian scholarly group which flourished in the ninth and tenth centuries. In India, however, the method of measuring the human figure in terms of one module, viz., *tāla*, was known at least as early as the seventh century (*Vishṇudharmottarapurāṇa*). Thus it is possible that both the Arabs and Byzantine artists borrowed their form of measurement from India, specifically through Buddhist iconometric texts which would have been available in the Central Asian world from earlier times.

9. A. K. Coomaraswamy, *The Transformation of Nature in Art*, New York, 1934, p. 115.

10. Quoted by Panofsky, op. cit. p. 64.

11. Those who are interested in yoga and its relationship to images and art will profit from reading M. Eliade's *Yoga: Immortality and Freedom*, New York, 1958.

12. S. Kramrisch, *Indian Sculpture*, Calcutta and Oxford, 1933, p. 59.

13. Alphonso-Karkala, op. cit., p. 147.

1. Nara-Nārāyaṇa
Uttar Pradesh; Ahichchhatra (?)
5th century
Terra cotta
h: 22½ in. (57.2 cm.)
M.69.38

Representation of the Nara-Nārāyaṇa theme appears to be an invention of the Gupta period, although the myth is much older. The occasion is a discourse at the forest hermitage of Badarī between Nara, representing man, and a sage called Nārāyaṇa, who is identified with the god Vishnu. Nara too is partly divine and in

Vaishnava literature is identified with Arjuna, one of the heroes in the epic *Mahābhārata*. In this relief the hermitage or *āśrama* is symbolized by a solitary tree. The slightly obese figure with his right hand raised to his chest and a rosary in his left hand represents Nara; Nārāyaṇa is the faceless sage with a prominent ribcage, holding a book. Another book is placed on a wicker table between the two.

A terra cotta panel of impressive proportions, it reflects the classic simplicity and elegance of the Gupta tradition. Both figures are seated at ease and their forms are modeled with economy and grace. Symbols are used sparingly to depict the locale, but the figures themselves convey the tranquil atmosphere of the hermitage. Subtle gestures of the hands or a slight turn of the head are sufficient to express the interaction of the two figures.

Published: Pal, 1970-71, p. 77, fig. 3; Trabold, fig. 9.

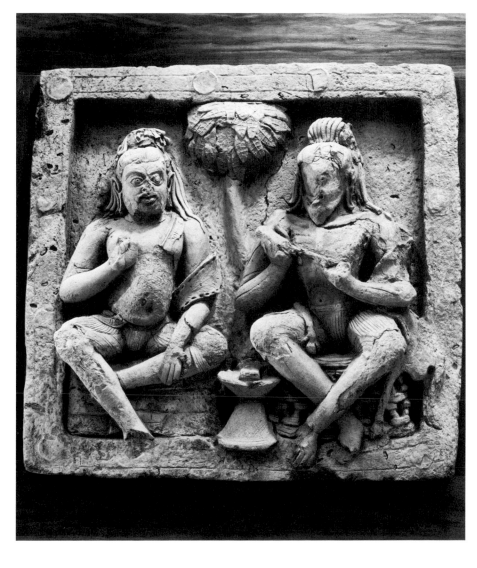

2. Sleeping Vishnu

Rajasthan or Gujarat
11th century
Buff sandstone
h: 22 in. (55.9 cm.)

When he is not active as the preserver of the universe, Vishnu is said to sleep like a hibernating bear on the coils of a multi-headed serpent known as Ananta (eternity). Ananta is said to float in the cosmic ocean, but here the sculptor has placed him on a cot. Below the cot are several seated figures and a horse, which may be a sacrificial animal. Vishnu supports his crowned head with one of his right hands; the other holds the mace. One of his left hands holds the wheel, and the other grasps the conch-shell. From his navel emerges a lotus on which is seated the figure of Brahma. Vishnu's consort Lakshmī is busy massaging his foot, and two other females are also in attendance. In the upper band of the relief are portrayed the seven mother goddesses and the seven known planets worshiped collectively by the Indians as the Navagraha. Not only is this a rare representation of this cosmic subject in collections outside India, but it is also very well preserved. This iconographically rich relief introduces some unusual features such as the depiction of a cot instead of the ocean and the inclusion of the deities along the top. As is usually the case with Indian art, Vishnu's superiority is emphasized by contrasting his much larger figure with the miniature representations of other gods. The voids around his slim but angular form help to clarify the otherwise crowded composition. Indeed, the zig-zag pattern created by his supine form alleviates the strong emphasis on the horizontal caused by the upper and lower bands of figures.

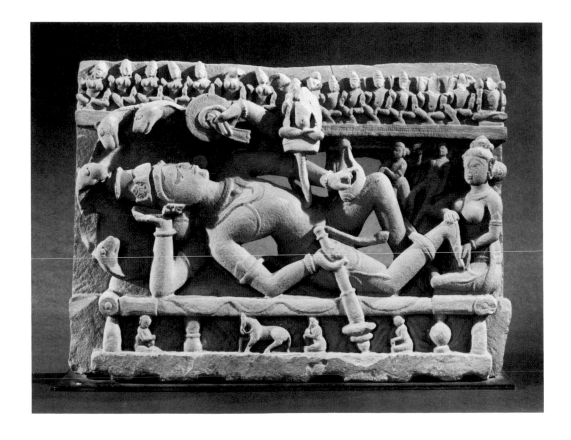

3. Lakshmī-Nārāyana

Kashmir or Himachal Pradesh
11th century
Bronze with silver inlay
h: 7 in. (17.8 cm.)

This image is the Vaishnava counterpart of the Śaiva Umā-Maheś-vara representations (nos. 12-14). Here Lakshmī and Nārāyaṇa—the name used for Vishnu in such images—are seen in an attitude of intimacy. Vishnu, holding the mace, the lotus, the wheel, and the conch, sits astride his mount Garuḍa: and Lakshmī, holding a lotus, is perched on her husband's left thigh. Garuḍa has outspread wings and holds a pot containing nectar.

This particular composition became quite popular in Kashmir and Himachal Pradesh about the tenth century. A number of images in stone have been recovered from the Verinag area in Kashmir, and the Los Angeles County Museum of Art has a fine example in the Heeramaneck Collection. The style of this bronze, however, relates more closely to bronzes found in the mountain valleys of Himachal Pradesh and hence the uncertainty of its provenance (cf. P. Pal, *Bronzes of Kashmir*, figs. 7, 90).

Published: Davidson, p. 61, no. 78.

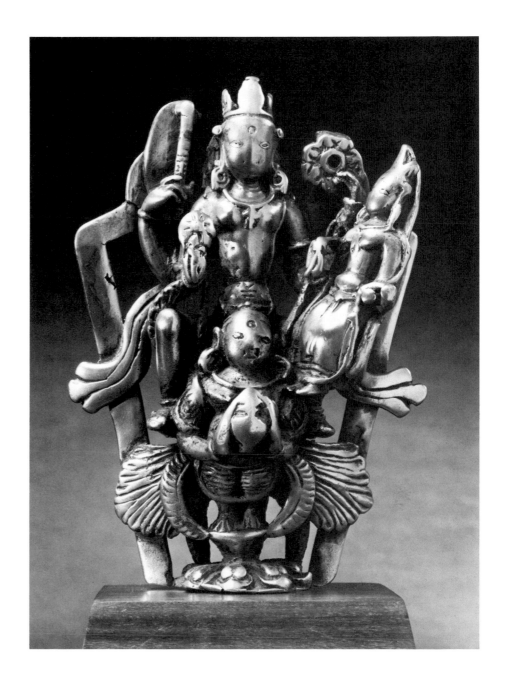

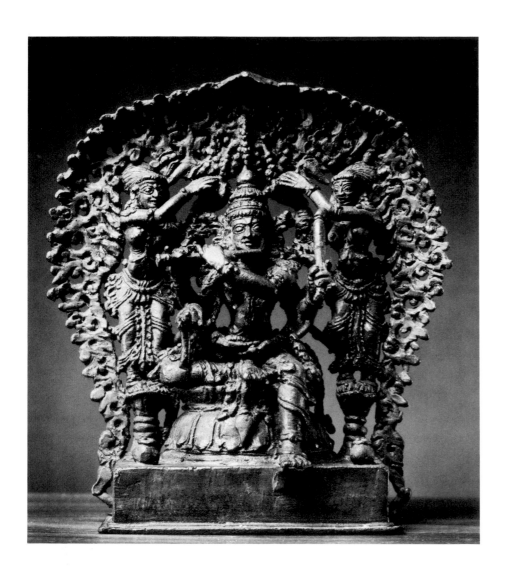

4. The Lustration of Krishna-Vishnu
Kerala
16th–17th century
Bronze
h: 6⅞ in. (17.5 cm.)

The eight-armed god, crowned and richly ornamented, is seated in *lalitāsana* on a lotus with his left leg pendant. Two of his hands are in the gesture of meditation (*dhyānamudrā*) in his lap; two others are engaged in playing the flute; and the remaining four hold the typical Vishnuite attributes, a conch, a wheel, a mace, and the seed of the lotus. On either side are two tall and slim females who are pouring water from pots over the god's head; two more pots are placed on the pedestal. All the figures are represented below an arbor that is intricately patterned and perforated.

The central figure seems to combine the three basic concepts that were synthesized to form the composite personality of epic-puranic Vishnu. The hands showing the meditative gesture emphasize his yogic aspect and probably symbolize Nārāyaṇa, the cosmic deity. The flute player is of course Vāsudeva-Krishna, the cowherd hero-god of Brindavan, and the remaining four hands represent the Vishnu aspect.

5. A Vaishnava Deity
Kerala
16th–17th century
Bronze
h: 6¾ in. (17.1 cm.)

There is very little to indicate that this represents a divine figure. He did possess an aureole once, which was separately attached, and a tiny nimbus (*śiraśchakra*) is affixed to the back of the head. He sits in the heroic posture known as *virāsana*, rarely encountered in religious images. His left arm rests on his left knee and the right arm forms the teaching gesture (*vyākhyāṇamudrā*). Both ears are adorned with earrings in the form of a *makara*, a mythical animal combining an elephant's trunk with a fish's body. The tall crown, together with the posture, enhances the figure's majestic bearing, and his benign nature is made apparent by his slightly smiling countenance.

Although an exact identification is difficult because of the tall crown, the figure probably represents a deity of the Vaishnava group, possibly Dhanvantari, the divine physician who is considered an emanation of Vishnu.

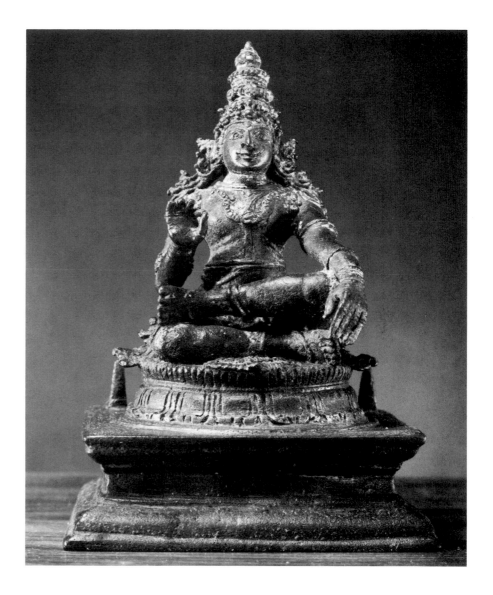

6. Cow and Calf

Uttar Pradesh
7th–8th century
Pink sandstone
h: 20½ in. (52.1 cm.)
M.73.87.2

This relief of a cow suckling her calf may have belonged to a larger composition depicting the miracle of Krishna holding up the mount Govardhana to shelter the cows of Brindavan from a storm.

Usually in such reliefs several cows and calves are represented on either side of a heroic figure of Krishna. Both animals here are delineated with remarkable economy yet the portrayals are convincingly naturalistic. The modeling is subtle though animated and is strongly reminiscent of the classical style of the Gupta period (300–600).

Published: Pal, 1974, p. 31.

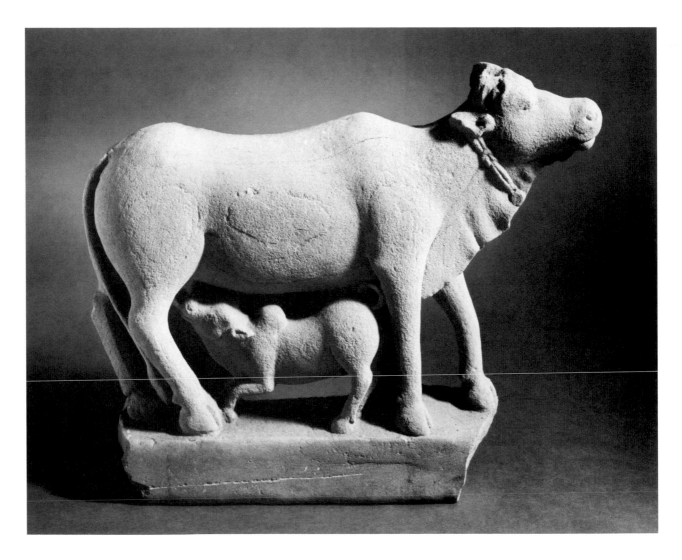

18

7. A Goddess

Kerala
16th century
Bronze
h: 14 in. (35.6 cm.)

This bronze was very likely part of a larger shrine. From the tilt of her body and the flame design along the edge of the frame on her right, it would appear that she once stood on the right of a central deity. This, together with the lotus held by her right hand and another lotus adorning the summit of her crown, leads us to suggest that the goddess probably represents Śrī-Lakshmī, the consort of Vishnu. She is also the goddess of wealth and is universally worshiped in every Hindu home. However, such isolated female figures are difficult to identify because Pārvatī, the consort of Śiva, is also given the same form and holds a lotus.

This is an impressive example of Kerala bronzes revealing a strong penchant for decorativeness in the jewelry as well as for the richness of the garment. Kerala bronzes of this period are further distinguished by distinctive physiognomical features: strong aquiline noses, pointed chin, and large staring eyes. Kerala sculptors seem to have inherited their love for ornamentation from the florid Hoysala style that prevailed in Karnataka in the thirteenth and fourteenth centuries.

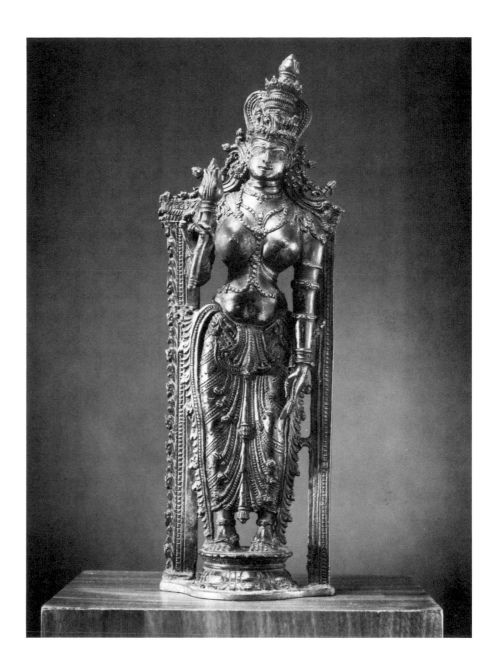

8. Mukhaliṅga
(Phallus with a face)
Uttar Pradesh, Mathura
Late 4th century
Spotted red sandstone
h: 12 in. (30.5 cm.)

When a face is carved against
Śiva's phallic symbol, it is known
as a *mukhaliṅga*, an icon which
became extremely popular in
northern India after the third
century. This is a particularly
handsome example from
Mathura. The top of the phallus,
which originally extended a few
inches beyond the chignon, is
broken; a decorative band
surrounding the phallus,
however, can be seen at the sides.
The face is a classic example of
Gupta sculpture reflecting ideal-
ized features that are character-
ized by both simplicity and
nobility, but the moustache, not
a common feature of the Gupta
age, is a survival from the Kushān
period. The third eye of the god,
symbolizing fire, is clearly delin-
eated and the elegant hair-style,
known as a *jaṭāmukuṭa* or a crown
of matted hair, is held by a simple
string. His two normal eyes are
symbols of the sun and the moon.

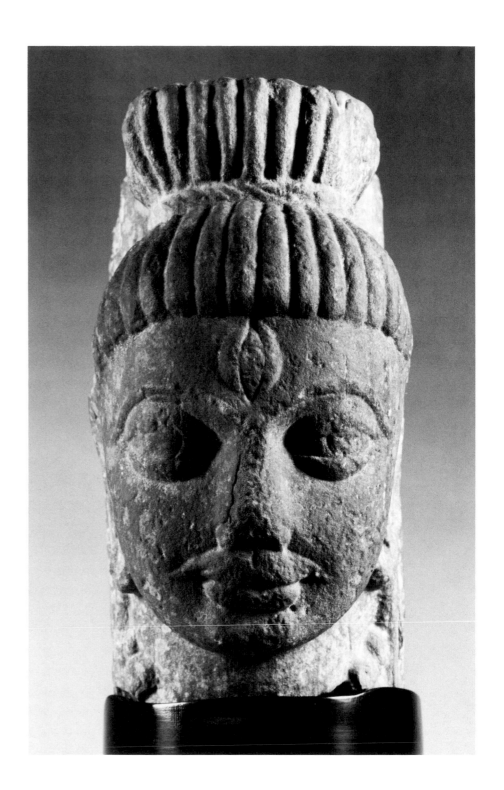

20

9. A Cow Adoring the Sivaliṅga

Tamilnadu
8th–9th century
Buff granite
h: 21¼ in. (54.0 cm.)
M.76.48.1

Within a niche, formed by the billowing tongue of a lion, a cow is seen licking a Sivaliṅga in adoration (see no. 8). At the lower right of the relief a dwarf or child rides upon a *makara*; the same motifs on the opposite side are broken. Several lively lions decorate the outside of the arch and appear to be climbing the ledge of a cave.

The cow adoring the Sivaliṅga probably represents the legend of Govindaputtur, a site on the bank of the river Kollidam in the state of Tamilnadu. According to the story, there was an important Saiva temple at that site in the seventh century where a cow attained salvation by worshiping the *liṅga* known as Tiru-Vijaymangai.

Stylistically the sculpture is closely related to monuments *in situ* in the southern part of Tamil-nadu created when the region was ruled by a dynasty known as the Pandya. This relief probably served as a tympanum for either an excavated or a structural temple. Although somewhat abraded, the animals are remark-ably well executed. Especially naturalistic is the pose of the cow, who turns her head exactly as a living cow would to lick her nursing calf. By contrast, the lions are stylized but animated, as they usually are in Indian sculpture.

Published: P. Pal, 1976, fig. 6.

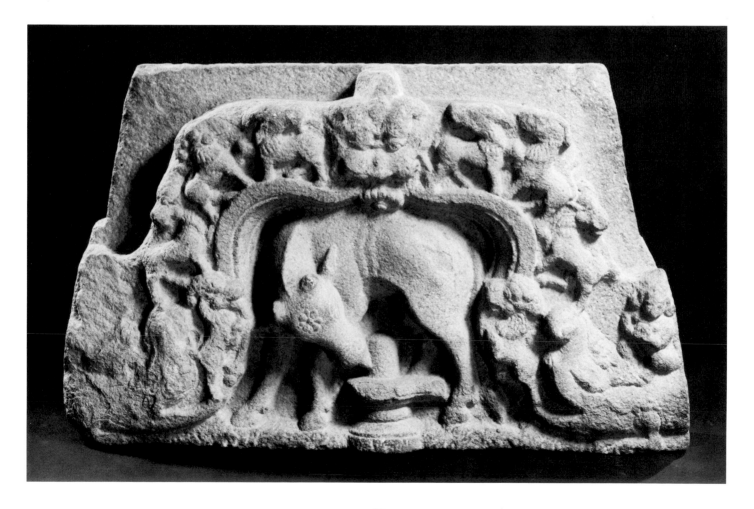

10. The God Siva
Kerala
11th century
Bronze with green patina
h: 9⅛ in. (23.2 cm.)

Siva is represented here in a classic image type known as Chandraśekhara, the god who is adorned by the moon. The crescent moon can be seen at the top right hand corner of his tall crown-like chignon. He stands on a lotus in the strictly frontal posture known as *samapada*. With his two upper hands he holds the battle-axe and the deer; his lower right hand is in the gesture of charity and holds the seed of the universe, and his lower left hand rests against his hip. His right ear is adorned with a *makara* ornament and the left with a circular earring.

Stylistically the bronze is related to Chola bronzes of the eleventh century and like them is well modeled and finished at the back. However, there are certain notable differences that may indicate another provenance for this handsome figure. The physiognomical features as well as the design of the garment are quite distinct from Chola bronzes. The modeling too is somewhat different, especially in the greater prominence given to the buttocks by pulling in the pelvic area. Although removed by centuries, the features anticipate the type of face that became standard for the later Kerala bronzes (nos. 4, 5).

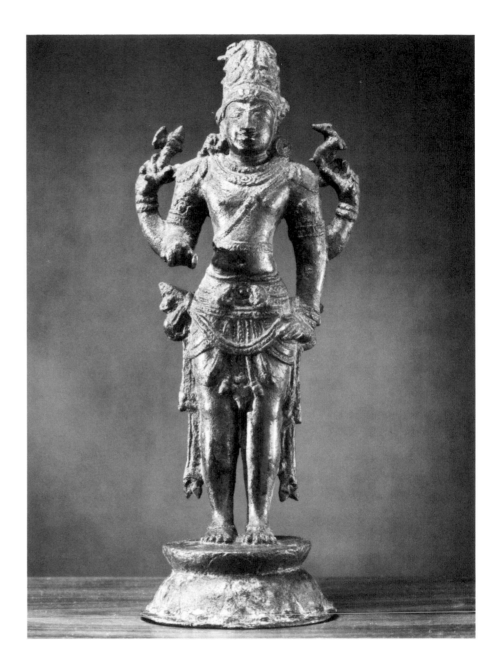

22

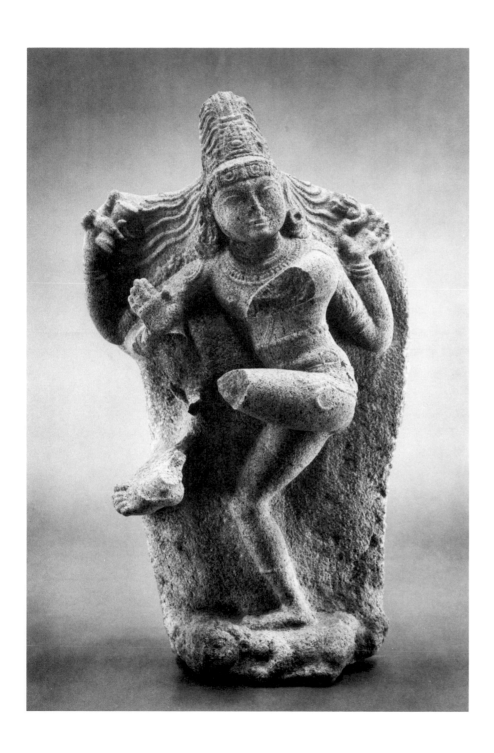

11. The Lord of the Dance (Naṭarāja)
Tamilnadu
12th century
Grey granite
h: 33 in. (83.8 cm.)
M.71.82

Siva is regarded as the supreme teacher of all performing arts, and his portrayal as the Lord of the Dance or Naṭarāja is one of his most popular representations in South India. Stone images like this of dancing Siva were placed in niches on the external wall of a temple, while bronze sculptures were carried in processions. Bronze Naṭarājas are seen frequently in museum collections but South Indian stone images are rarely found outside India.

With his hair flying on either side of his head, Siva dances on the back of a dwarf symbolizing ignorance. His upper right hand holds the kettle drum which provides the rhythm for his dance and also symbolizes creation. The fire in his upper left hand is symbolic of dissolution. The raised right hand displaying the gesture of reassurance signifies preservation, and the now-broken left hand would have pointed to his left foot which is the source of salvation. The dance of Siva is therefore a symbolic dance which embodies the entire cosmic process.

Published: P. Pal, 1976, p. 56, fig. 7.

12. Umā-Maheśvara

Uttar Pradesh
10th century
Cream sandstone
h: 33¾ in. (85.7 cm.)
M.75.11

Images in which Siva (Maheś-vara) and Pārvatī (Umā) are represented seated together in an attitude of intimacy are known as Umā-Maheśvara-mūrti. Usually the composition of such steles is elaborate, though strictly symmetrical. The divine couple is generally accompanied by other members of the family as well as celestial personages, making the sculpture a kind of "family portrait."

In this remarkably well preserved and finely carved image, the principal couple in a fond embrace are seated on a ledge above the imposing figure of the bull Nandi. In front of Nandi is the emaciated dancing figure of Bhṛingi, the most devout of Siva's acolytes. Among the attendant figures are the couple's sons, Gaṇeśa and Kumāra, seated on either side of Nandi. Above two nimbate attendants are a celestial couple, each standing on a lotus and offering garlands, and above them two ascetics or Saiva priests sit reverentially on two other lotuses. Immediately above the nimbus behind Siva's head are the five *liṅgas* or phallic symbols of the god and on either side are the meditating figures of Brahma and Vishnu, the other two members of the Hindu trinity.

This is a fine example of a type of relief that is constantly used in a niche on the external wall of a medieval Saiva temple. Such steles therefore are conceived essentially in architectonic terms. Despite the large number of figures, the composition is organized with both clarity and visual harmony. The details are rendered with remarkable finesse; especially delicate are the fingers, the hairstyles, and the features of the gentle faces.

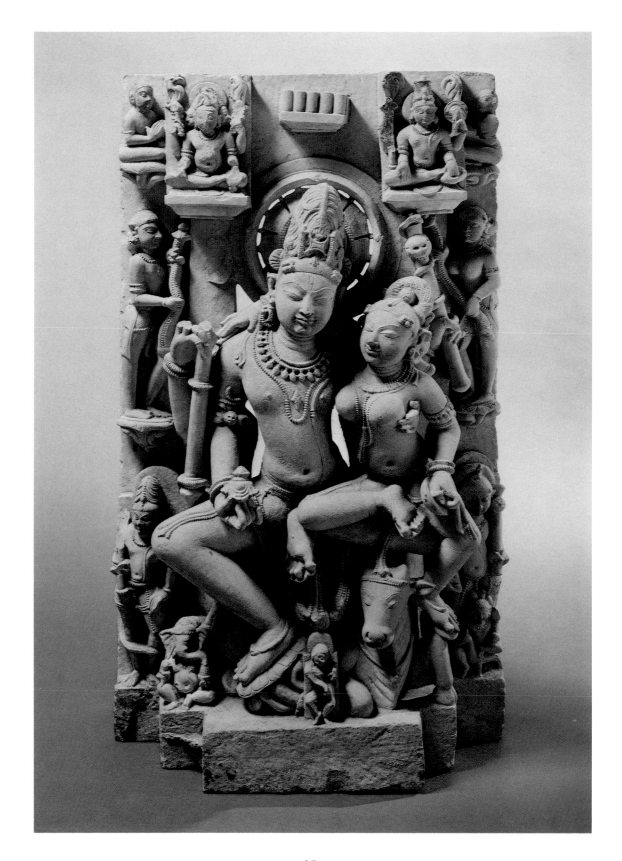

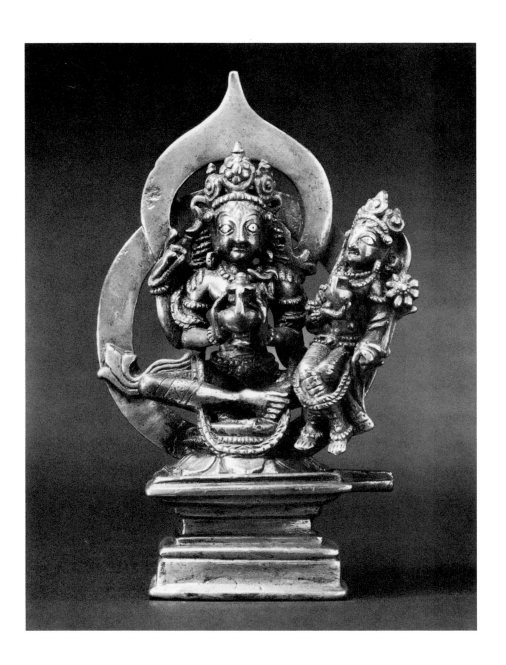

13. Umā-Maheśvara
Kashmir or Himachal Pradesh
11th century
Bronze with silver inlay
h: 6⅜ in. (16.2 cm.)

Although this may be regarded as an Umā-Maheśvara image, it presents interesting iconographic variations when compared to more conventional representations (nos. 12, 14). Here Siva is seated in the yogic posture on a lotus, and his principal hands hold a waterpot with leaves. His upper right hand grasps the rosary and the left supports Umā who is seated on his thigh. Umā too holds a waterpot with her right hand and a lotus with the left. Although bedecked with ornaments, Siva remains essentially a yogī, and his form and attribute here probably depict Kumbheśvara, Lord of the Waterpot.

Thus not only is this a rare representation of Siva as Kumbheśvara, but it is one of the few known bronze images of Umā-Maheśvara from either Kashmir or Himachal Pradesh. Such bronzes, usually of small size but nevertheless very charming, were generally worshiped in domestic shrines. The spout at one side of the pedestal was used to drain the excess fluids that had been poured over the image during ritual bathing.

14. Umā-Maheśvara
 Kerala
 16th–17th century
 Bronze
 h: 7½ in. (19.1 cm.)

Siva is seated on a lotus in *lali-tāsana* with his right leg pendant and the left folded parallel to the ground; Umā is perched on his left thigh. Siva holds the battle-axe on his right and the deer on his left; the lower right hand forms the gesture of charity and the remaining left hand encircles Umā and pinches one of her nipples. Umā's right arm embraces Siva and her left holds a lotus. Seated on lotuses on either side of the couple are their sons, Gaṇeśa and Kumāra. Siva's favorite bull, Nandi, is on a corner of the pedestal and is licking his master's toes. The figures are framed by an elaborate aureole decorated with swirling scroll patterns.

This representation of Siva and his family depicts a popular theme in Indian art. A comparison of the three examples included in this exhibition (see nos. 12, 13) not only reveals their stylistic differences but also reflects notable iconographic variations according to the particular religious needs of each region.

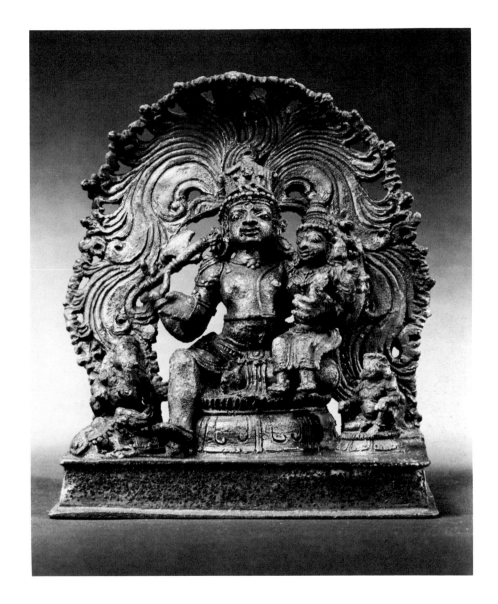

15. A Saiva Deity

Indonesia, Central Java
9th century
Grey volcanic stone
h: 14½ in. (36.8 cm.)

Although there is no third eye on the forehead, very likely this head once belonged to a deity of the Saiva group. Not only is his hair gathered in the characteristic *jaṭāmukuṭa* and adorned further with a tiara, but the skull is also a Saiva attribute. Strands of his matted locks fly out on either side of his head, which is an unusual feature generally seen only in dancing figures (no. 11). The head is attached to a nimbus announcing the figure's divine status.

Although the exact provenance of the head is not known, it is related closely to the figures in such well-known monuments as the Chandi Plaosan and the Lara-Djonggrang, both of the ninth century. This was a great period in the history of Java, when the Śailendras ruled in the central part of the island and built some of its finest temples. Characteristic of the sculptures of the period, the head expresses quiet dignity and the face has a particularly noble and serene expression.

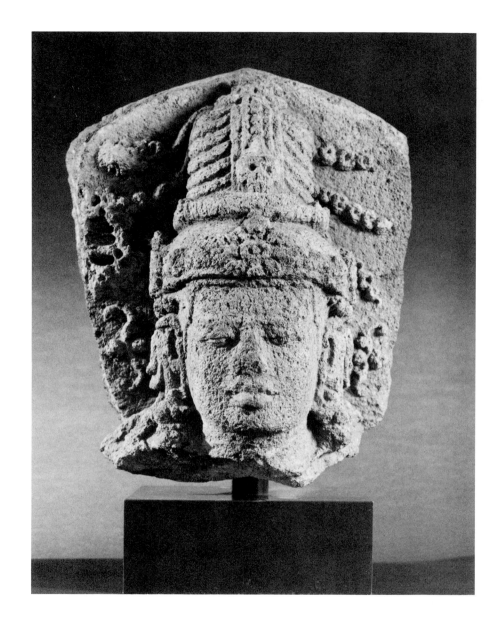

28

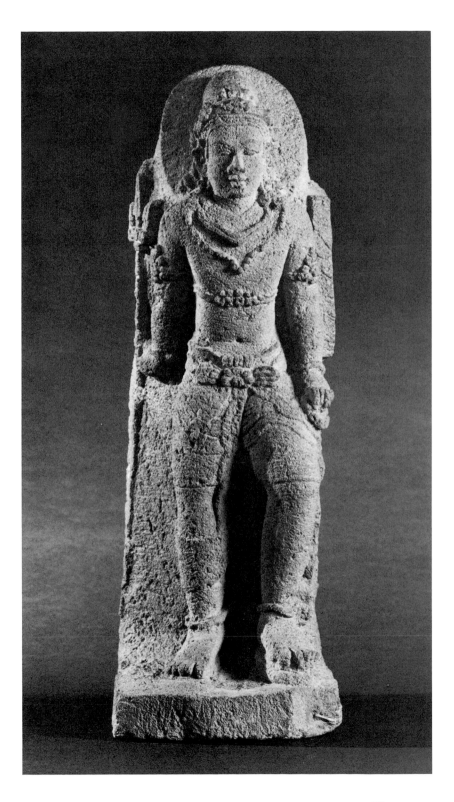

16. A Saiva Figure
Indonesia, Central Java
9th–10th century
Beige volcanic stone
h: 25 in. (63.5 cm.)

A tall and strongly built figure stands with his left leg placed forward and slightly bent, as if he is about to take a step. He wears a *dhoti*, is given various ornaments, and his divinity is announced by the plain, circular nimbus. The right hand appears to be pushed behind him and touches a trident. The left hand holds what may be a rosary resting against his thigh. Whether the third eye was marked on the forehead is not clear, but the presence of the trident definitely indicates a Saiva association. Thus the image could represent Siva himself, or another god of the Saiva family, or even a deified Saiva king. It was customary in Java, as elsewhere in Southeast Asia, to raise memorial statues of kings identified with the gods, although the portraits were not realistic.

Stylistically the sculpture could be compared with figures of celestial beings in the Siva-temple of Lara-Djonggrang (cf. Bernet Kempers, pl. 143) or with a Mahākāla image in the Musée Guimet in Paris (cf. le Bonheur, pp. 310-311). The similarity with the latter sculpture is especially striking. Furthermore, the position of the left leg is like that of a bronze Vishnu also in the Musée Guimet (ibid., p. 219).

17. Headpiece with Bhairava
Kerala
16th–17th century
Polychromed wood
h: 42 in. (106.7 cm.)
M.77.60

This spectacular wood sculpture, still retaining some of its original polychromy, must have been used as a headpiece for a large wooden image. The central motif is a head of Bhairava, the angry manifestation of Siva, and is rendered like a mask used in Kathākali dance. Bhairava's ear ornaments are carved elephants, and snakes are used profusely to adorn him as well as to create a lively border. A lion's head serves as the auspicious *kīrttimukha* or face of glory motif at the apex of the border, and two stylized lions play a heraldic role at the base. Garlands spring from *makara* heads and form a wide band along the edge of Bhairava's flying hair.

Wood has remained a favorite material for sculpture in Kerala since ancient times. Carved in three pieces and fitted together, this headpiece attests to the continued vitality of the tradition, even as late as the sixteenth and seventeeth centuries. Both in terms of compositional grandeur and refinement of carving, this headpiece remains a tour de force.

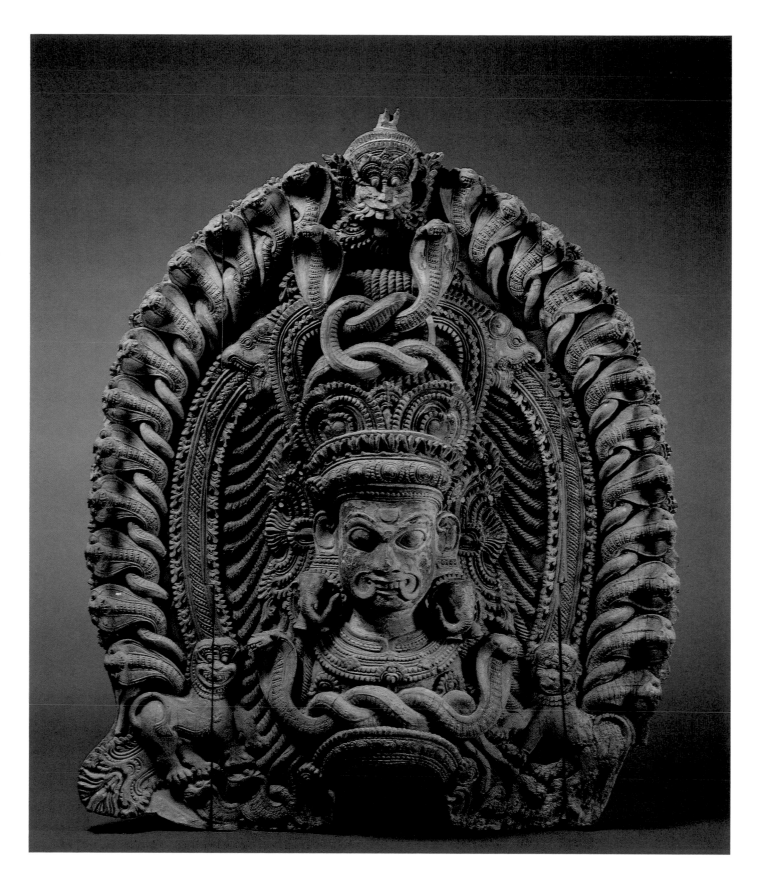

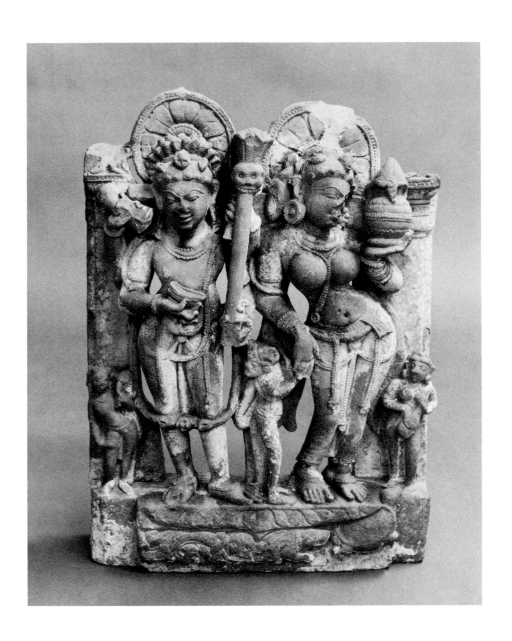

18. The River Goddess Yamunā and Companions
Madhya Pradesh or Rajasthan
8th–9th century
Beige sandstone
h: 28½ in. (72.4 cm.)
M.72.79.2

The voluptuous female, who stands with her hips thrust to her left and holds a waterpot, can be identified by the tortoise below her feet as the river goddess Yamunā. She is accompanied by two female attendants, one of whom holds a cosmetic bag. Beside her stands a male figure of equal proportions. He has four arms which hold a kettledrum, a bell, a skull-bearing staff, and a skull-cup. Other skulls adorn his elaborate hair and his garland. He is obviously a Saiva guardian, and hence the relief must have embellished a Saiva temple. A pair of such reliefs, portraying the goddesses of the two most sacred rivers, the Gaṅgā and the Yamunā, are usually placed as good omens on either side of an entrance in Indian temples.

Traditionally the size of the figures in such reliefs is determined by their relative importance; hence the attendants are all diminutive. In the extravagant opulence of the forms, the exaggerated postures, and the sumptuousness of ornamentation we note the baroque tendency of early medieval sculpture. The crowded effect of the relief, however, is considerably alleviated by the voids around the principal figures.

19. The Goddess Durgā
Orissa, Bhuvaneswar
11th century
Brown stone
h: 33¾ in. (85.8 cm.)
M.71.82

Against a background depicting a shrine with columns and an elaborate arch, the tall and stately figure of the goddess Durgā stands gracefully on an open lotus. She is richly adorned with necklaces, a torque, girdles, armlets, and a sumptuous crown. Her upper garment and tall crown are finely carved with intricate designs. Each of her four hands holds an attribute: a snake, a rosary, the staff of a broken trident, and the stalk of a lotus. Her diminutive attendants, Jayā and Vijayā, stand on either side, each on a smaller lotus, and carved in the right front of the base is the animated figure of a lion, the mount of the goddess. Above the arch are two flying celestials (*gandharva*) carrying garlands.

This is obviously a peaceful manifestation of the goddess, and the image probably embellished a niche on one of the side walls of a temple. Despite its hieratic character, the sculpture is informed with a flowing sense of movement, and the forms are modeled with verve and plasticity.

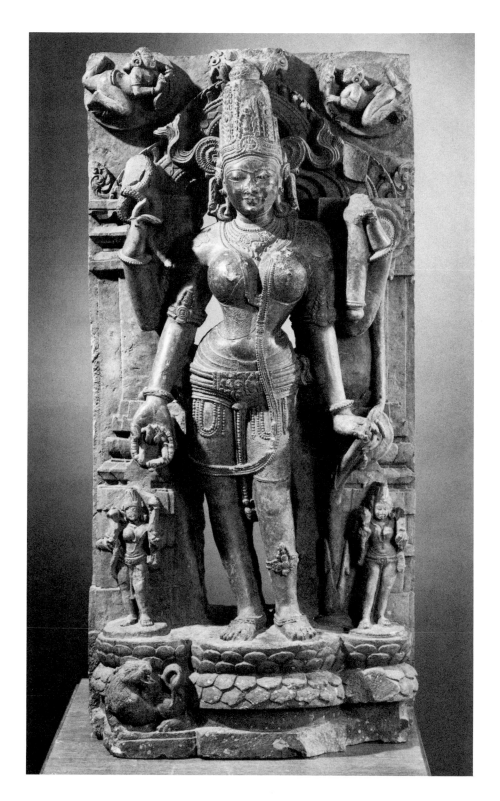

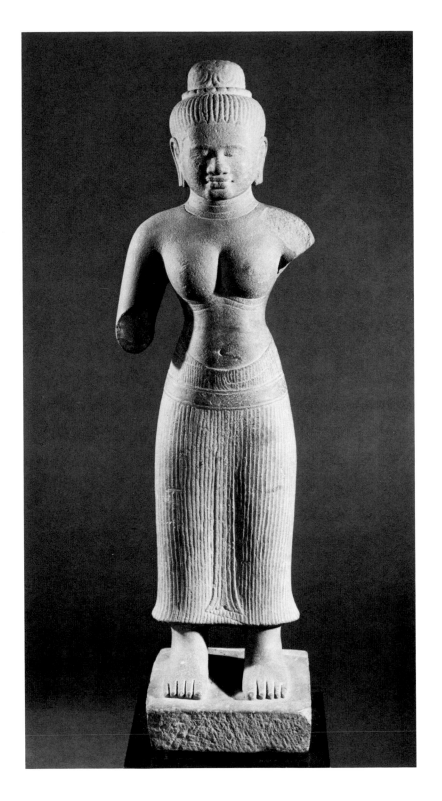

20. A Goddess

Cambodia, Baphuon Style
1050–1100
Brown sandstone
h: 21¼ in. (54.0 cm.)

With her arms broken, it is diffi-
cult to determine whether the
figure represents a goddess or a
deified princess or queen. It was
customary in Cambodia to apoth-
eosize the dead by carving statues
of divinities identified with the
deceased. Despite her idealized
form, the face of this figure does
reflect a certain degree of indivi-
dualization. The goddess is likely
to have been Umā, the consort of
Siva. The figure wears a sarong,
its simple pleats indicated by
closely placed, parallel lines. Her
hair is gathered in a bun held
together by a band; otherwise the
torso is completely bare and
without ornamentation.

This figure is rendered in a style
known as Baphuon, which can be
identified by the distinctive
physiognomy, chaste elegance,
and restrained sensuality of the
modeling. Such figures are also
characterized by gentle grace, and
their well-delineated garments
and ornaments are never allowed
to interfere with the form. Like
most freestanding sculptures in
Cambodia, the back of this figure
is as deftly modeled and as
precisely finished as the front.

21. A Yoginī
 Madhya or Uttar Pradesh
 c. 1000
 Buff sandstone
 h: 36 in. (91.44 cm.)
 UCLA Museum of Cultural
 History

A yoginī, literally a female yogī, is an emanation of the archetypal mother goddess. Sixty-four of them, known as Chaushāṭ Yoginī, are collectively worshiped by the Saktas. Although they have specific names, their iconography is not always clear and hence an exact identification is difficult. The mount of this goddess appears to be an owl; with her sixteen arms, some of which are broken, she holds various attributes. The most intriguing aspect of her iconography is the position of the two hands near her partly open mouth. By comparison with another and simpler representation of the goddess (see Pal, 1977, fig. 37), we can surmise that two of her fingers were inserted in her mouth, in which case she might be whistling. She may thus be a descendant of the more ancient spirits, known as Ḍākinī, who are said to have called (ḍāka) their intended victims away from the village and lured them into the forest, where they drank their blood.

Except for the implications of this peculiar gesture there is very little about her that is terrifying. On the contrary, she is as elegantly modeled as any of the benign goddesses. The composition is enriched by several other figures, both celestial and mortal.

Published: Davidson, p. 42.

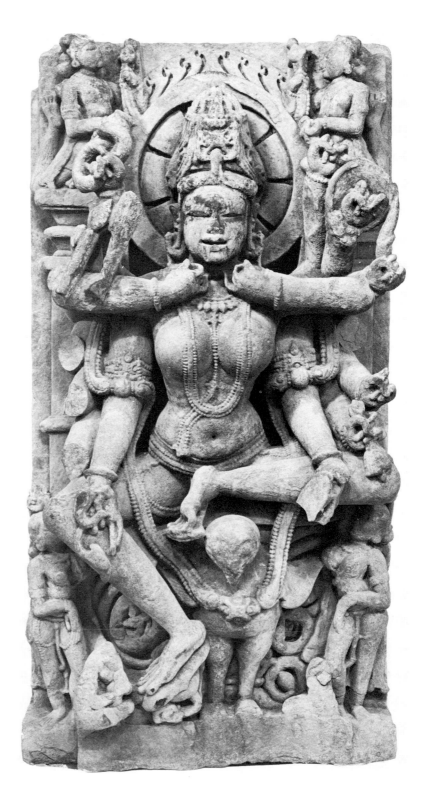

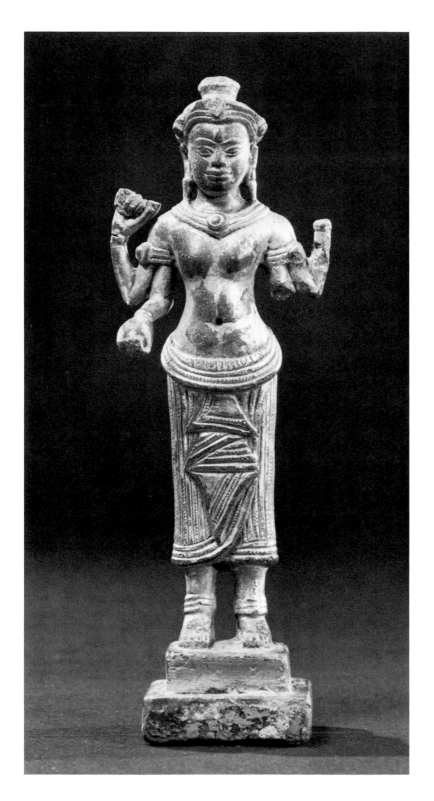

22. A Goddess

Cambodia or Thailand
12th–13th century
Gilt bronze
h: 5¼ in. (13.3 cm.)

With two of her arms broken, the exact identification of this figure is difficult to determine. The strictly frontal posture and the symmetrically disposed four arms are quite typical of Cambodian images that can portray several different goddesses. In one of her remaining hands she holds what may be either a wheel or a rosary and in the other she holds a boss which generally symbolizes fertility. She does, however, have a third eye which may indicate that she is either the Hindu Umā or the Buddhist Prajñāpāramitā, a goddess of wisdom. She wears a long skirt with the frontal folds rendered in a stylized, zig-zag pattern and she is appropriately crowned and ornamented.

A charming bronze, it may have been made either in Cambodia or Thailand. The stylized and mechanical folds of the garment would indicate a Thai origin, but the whole figure generally reflects a simplified version of the Bayon style of Cambodia. Compared to her Indian counterparts, her breasts are small and her figure is slight and slender, obviously reflecting a different physical ideal.

23. A Celestial Dancer

Cambodia, Banteay Srei Style
950–1000
Reddish sandstone
h: 12½ in. (31.7 cm.)

A celestial nymph is seen dancing within an elaborate niche. Although her arms are broken, her form is well preserved and her graceful posture echoes the pliancy of the scroll pattern that decorates the elaborate, multi-foiled arch. Except for a crown, the nymph is remarkably unadorned, unlike contemporaneous Indian sculpture which is frequently overwhelmed with rich ornamentation. There is an appealing balance between the simplicity of the figure and the exuberance of the scroll design on the enframing columns.

The crisp and lively carving of the arch is characteristic of the temple of Banteay Srei, an architectural jewel of the Angkor period. Although this small but charming relief did not belong to that temple, it is rendered in the same style. For a comparable relief in the Nelson Gallery-Atkins Museum, Kansas City, see Lee, 1969, fig. 19.

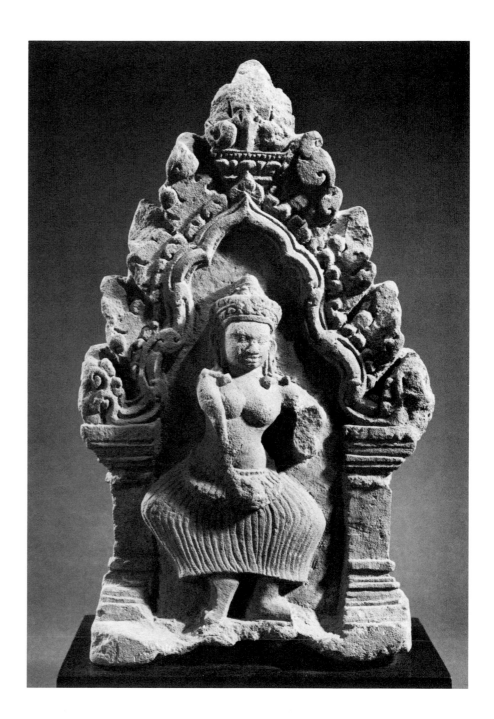

24. A Celestial Nymph

Madhya Pradesh, Khajuraho
11th century
Buff sandstone
h: 31 in. (78.7 cm.)

Celestial nymphs are a ubiquitous feature of the sculptural program of the medieval Indian temple. They are the descendants of the *yakshīs* and nature spirits of early Indian art and continue to reflect the abiding interest in fertility cults. This dancing figure announces her association with fecundity not only by the amplitude of her form, but by the mango tree above her head. She probably served as a bracket figure in one of the temples at Khajuraho, the capital of the Chandella Dynasty.

Although her form is as full and sensuous as earlier *yakshīs*, the modeling has hardened considerably and a greater interest is expressed in ornamental details. This decorative impulse is also evident in the treatment of the stylized tree which looks more like a canopy. The movement of the body is still lively, and the figure has a mannered elegance that is characteristic of much medieval Indian sculpture.

Published: Davidson, p. 49.

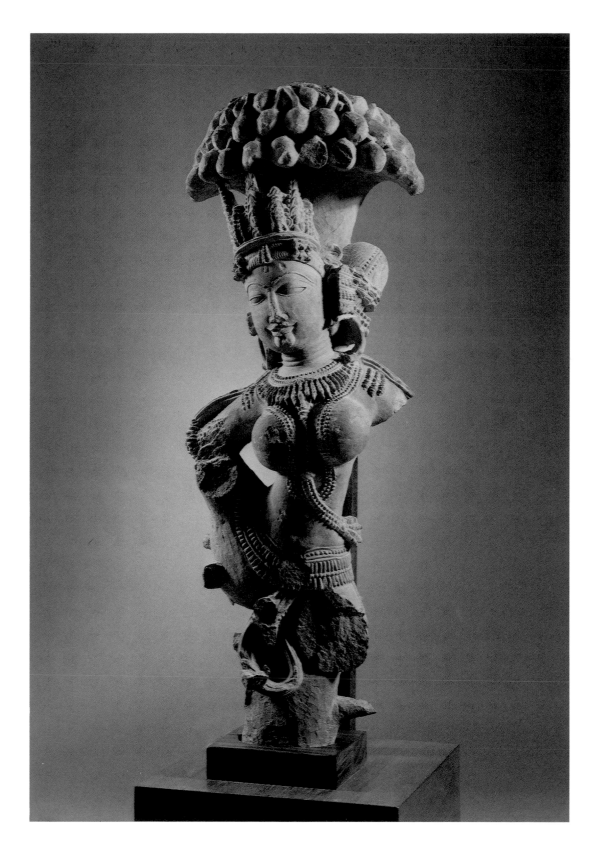

25. A Celestial Nymph

Orissa, Bhuvaneswar
11th century
Rust-colored volcanic stone
h: 28 in. (71.1 cm.)
M.76.48.2

Standing on a flower with her legs crossed and her left arm raised over her head, this nymph strikes a provocative posture. She seems to be cavorting with several dwarfs or monkeys who are busy disrobing her. She is obviously amused and indulgent. Such charming female figures, whether depicting a celestial nymph (*surasundarī*) or an indolent heroine (*alasakanyā*), were extremely popular with medieval Indian sculptors. They are the descendents of the tree dryads of early Indian art and the predecessors of the heroine or *nāyikā* of later Indian painting. Obviously the joyous and captivating posture of this lady is taken from the dancer's repertoire.

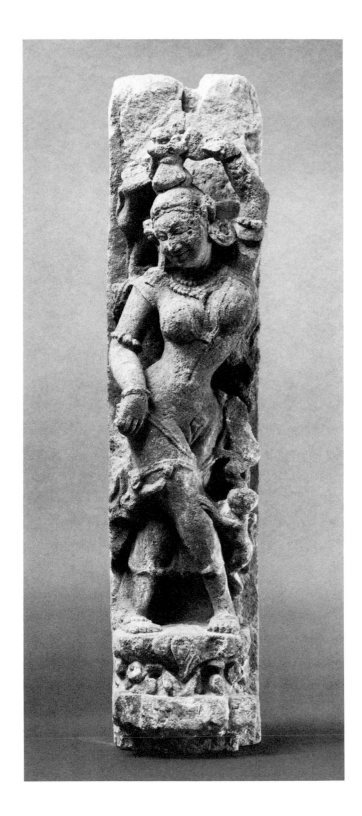

26. The God Revanta

Uttar Pradesh; Sarnath Region
7th century
Beige sandstone
h: 23 in. (58.4 cm.)
M.73.87.1

One of the earliest representations of the god Revanta in Indian art, this relief portrays the god as the divine hunter. Dressed like a Scythian in boots, trousers, and a coat, the god holds a drinking cup in one of his hands as he rides a horse. A dog licks his foot, and an attendant holds a parasol above the god's head. Two more attendants lead the group, one holding a flask in his hand ready to pour wine; a fourth figure in the upper left corner carries the trophy of the hunt, perhaps a wild boar. Below is a frieze of musicians who appear to be flying through the air.

But for its strictly frontal and schematic representation, there is nothing in the stele to signify that it portrays a divine rather than a human subject. No halo announces Revanta's divinity, and in fact his figure is no larger than that of his attendant; the scene could as well be a genre study of a group of merry hunters returning with their kill. Both the concept and inconography of Revanta, who is regarded as a son of Sūrya, the Sun-god, and who was subsequently worshiped as a patron god for horse-traders, developed during the Gupta period and may have been inspired by Iranian hunting reliefs. Note the Phrygian caps worn by all the figures. It may

further be pointed out that hunting themes also are preeminent in the coins of the Gupta emperors, probably reflecting Sassanian influence, as does the theme of Revanta.

Published: Pal, 1974, p. 18; Sharma, 1975, dust jacket and frontispiece.

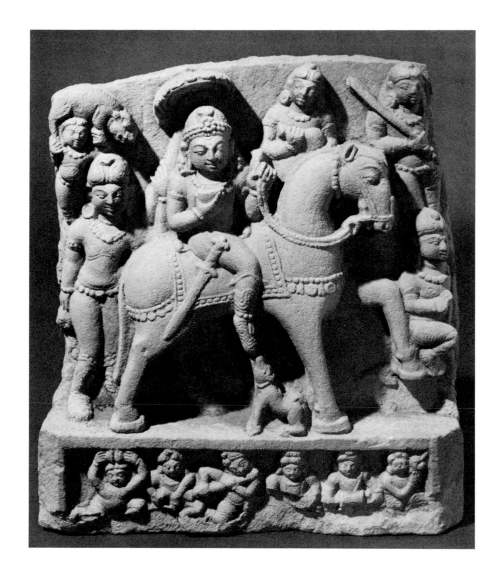

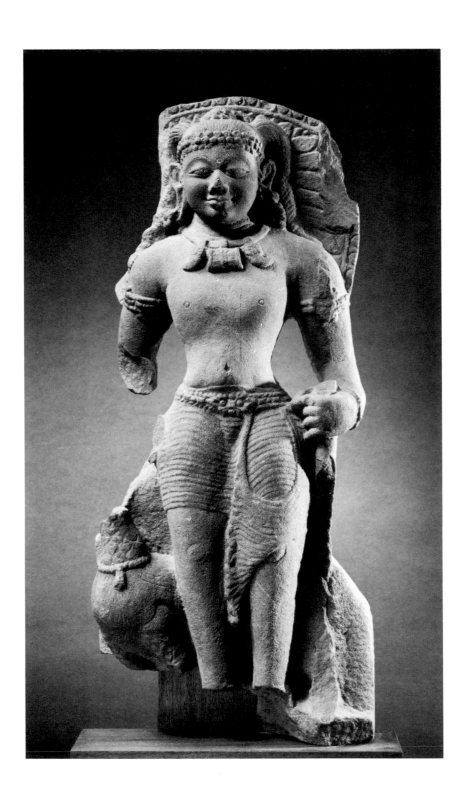

27. The God Kumāra
Madhya Pradesh
7th–8th century
Rust colored sandstone
h: 28½ in. (72.4 cm.)
M.77.4

Kumāra, known also as Kārtti-keya or Skanda, is the son of Siva and Pārvatī and is the divine general. He is always portrayed as a princely youth, as in this sculpture, and his youthfulness is emphasized by his hairstyle consisting of three braids (*triśikha*) and his necklace of tiger-claws (*vyāghranakha*). The hair-style was fashionable for small boys in ancient India and the tiger claws were used as charms to ward off evil. In this particular image the divinity of Kumāra is indicated by the lotus nimbus and his hieratic stance. His left hand holds the stem of a spear and the right hand, now missing, may have been feeding the peacock whose headless body can be seen behind the god.

Although belonging to the early Middle Ages, the sculpture still strongly echoes the influence of Gupta aesthetic. The powerfully modeled body is contained by a smooth and mellifluous outline, and the ornamentation is kept to a minimum. The eyes are still half shut, and the face betrays a smiling expression. The flap of the short *dhoti* is rendered with stylish elegance as it is brought forward to spread out like a fan across the left thigh.

28. The God Gaṇeśa

Indonesia, Central Java
10th century (?)
Grey volcanic stone
h: 23¼ in. (59.1 cm.)

Gaṇeśa, distinguished by his portly body and elephant head, is the god of auspiciousness and the remover of all obstacles. Hence, he is universally popular not only in India but also in those countries of Southeast Asia that came under the influence of Indian civilization. Here he is shown seated and is given four arms. His attributes are a rosary, partly broken, a battle-axe, and a bowl of sweets which he is busy eating. His lower right hand simply touches his calf and may have held part of his broken tusk.

Gaṇeśa's posture, with the soles of his feet facing each other, is typical of Javanese representations and to my knowledge is not encountered anywhere in India. His form and iconography, however, show very little deviation from the original Indian models. The general simplicity of this sculpture seems to indicate an early date.

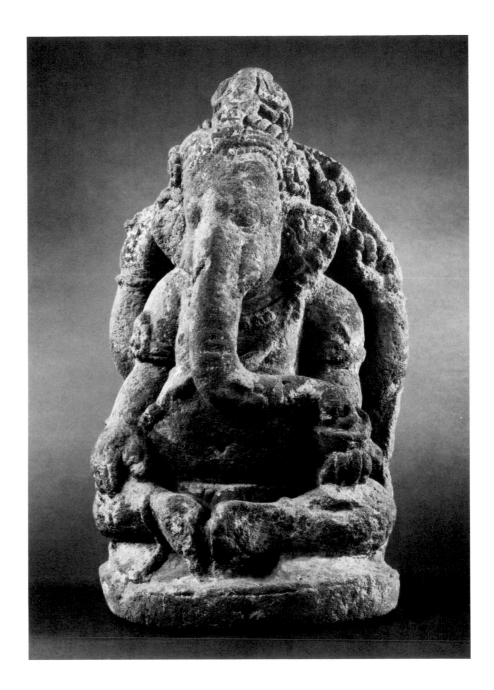

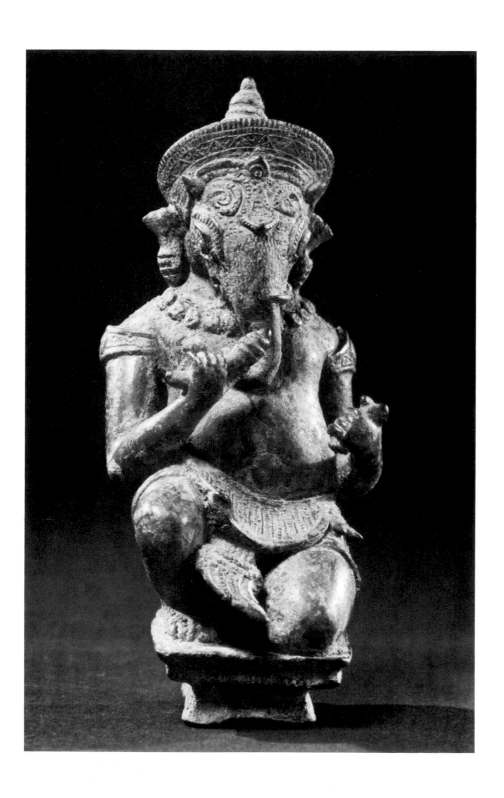

29. The God Gaṇeśa
Cambodia,
12th–13th century
Bronze with green patina
h: 4½ in. (11.4 cm.)

The god Gaṇeśa (see no. 28) is portrayed here as a semi-kneeling figure with only two arms. His right hand holds one of his broken tusks and the left a book. Thus, in addition to his role as the remover of obstacles, here he is also depicted as a god of wisdom. This posture for the god is unknown in India but is common in Cambodian iconography. It appears to be the posture in which kings sat on their thrones as described in Chinese literature: "When the king sits down, he sits sideways, raising his right knee and letting his left knee fall to the ground." (As quoted by G. Coedes, p. 59.) We can also assume that the crown and the ornaments are similar to those worn by Cambodian kings on ceremonial occasions. The decorative design on his trunk reflects the love of ornamentation that characterizes Cambodian sculpture of this period. The bronze was probably part of a larger shrine.

30. Kāla Head

Indonesia, Eastern Java
13th century (?)
Grey stone
h: 17 in. (43.2 cm.)

This motif, known as *kāla* in Indonesia, is, along with the *makara*, a ubiquitous feature of ancient Javanese architecture. In one form or another, it is present in every temple, either above the lintels, crowning the niches, or at the apex of arches. Often associated with a tree, it is derived from the Indian *kīrttimukha* or face of glory, which is a stylized lion's head (see no. 17). In Java, however, the motif assumed a more demonic character and became an almost totally different creature. The Sanskrit word *kāla* means time or death, and generally it is a synonym for Siva. However, in Java the motif occurs on all temples.

This *kāla* head is from eastern Java, where various innovations were introduced in the iconography of the motif probably around the twelfth century. First of all, it was dissociated from both the tree above its head and the *makara*, as was the practice in central Java. Second, two horns were added, as were the hands. It is interesting to note the curious affinity of this motif with the mythical creature that carries the Buddha in the Mon-Dvāravatī relief (no. 33). The horns appear there too, while the hands are included in earlier Cambodian renderings of the same subject. Thus, new influences appear to have arrived in eastern Java from the north around this period.

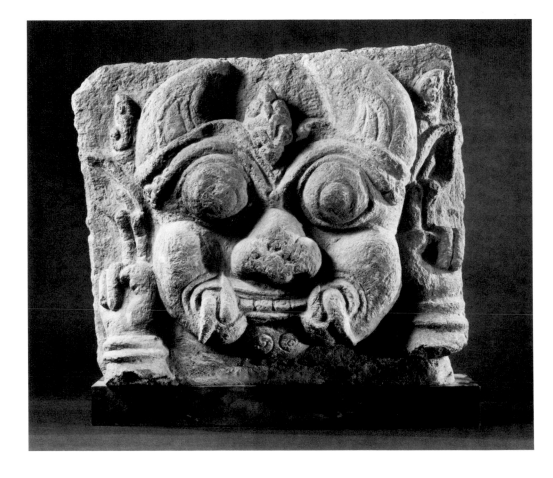

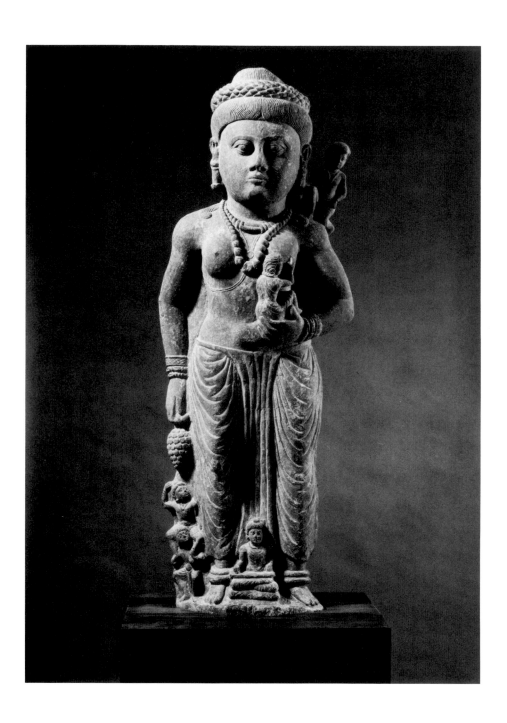

31. The Goddess Hāritī
Pakistan (Ancient Gandhāra);
Swat Valley
4th century
Grey schist
h: 43½ in. (110.5 cm.)

Her feet firmly planted, the goddess stands like a column, towering above the other figures. She wears a long skirt-like *dhoti*, but her torso is bare. Her hair is richly coiffed and she is adorned with various ornaments including strands of pearls and anklets. Her right hand holds a fruit symbolizing fertility and the left supports a child at her breast. Another child is perched on her left shoulder while two more cavort beside her right leg. In between her feet is the seated figure of a Buddha.

The sculpture is said to be from the Swat valley and reflects a regional variation of the Gandhāra style. Similar images of Hāritī surrounded by children are common in the art of Gandhāra, although the inclusion of a Buddha image between the feet appears to be an iconographic novelty. Hāritī was originally a child-devouring goddess but was converted into a benign madonna by the Buddha. She was the presiding deity of the refectory in all monasteries, and her consort is Pañchika or Jambhala, one of the wealth-bestowing deities. Although belonging to the Gandhāra tradition, this sculpture is stylistically quite distinct both in terms of its formal characteristics as well as the physical features of the goddess.

32. Buddha Śākyamuni
Thailand, Mon-Dvāravatī
School
7th–8th century
Polychromed terra cotta
h: 5⅝ in. (14.2 cm.)

Diminutive and fragmentary as it is, this is one of the finest examples of the polychrome terra cotta Buddha images that have survived from the Mon period (6th–9th century) of Thailand. Apart from the facts that a kingdom by the name of Dvāravatī flourished during this period and the predominant religion was Buddhism, almost nothing is known of the socio-political history of the region. The Buddha images created by the unknown Mon artists exerted a profound influence upon the Buddhist arts of Southeast Asia.

In its turn, the Mon or Dvāravatī style Buddha, as seen in this example, is a synthesis of the Buddhas created in the Amaravati and Sarnath schools in India between the third and fifth centuries. In essence, it is a sensitive and moving portrayal of the profoundly spiritual qualities of the Gupta Buddha. Wearing his red robe (saṅghāti), the Buddha appears serene and elegant with his idealized face expressing both compassion and inner calm through the half-shut eyes that stare at the tip of the nose. For a more complete and almost identical image see Boisselier and Beurdeley, p. 76, fig. 42.

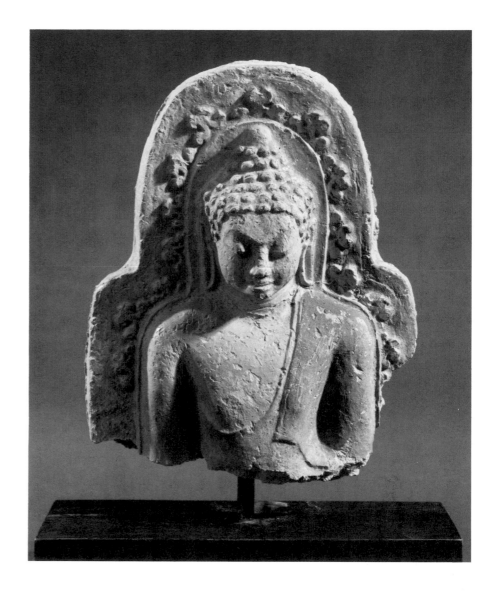

33. A Buddhist Triad

Thailand
8th–9th century
Grey sandstone
h: 31 in. (78.7 cm.)
M.77.83

This sculpture represents a unique iconographic type that was quite popular in Thailand during the Mon-Dvāravatī period but is not encountered in later periods of Thai art or in the Buddhist art of any other region. It shows three figures riding a mythical creature that at times looks like a garuḍa but at others like a composite avian creature of fancy. The central figure is always of Buddha who is usually shown standing but occasionally is seated. He is accompanied by two attendants, who may be either Bodhisattvas or the Hindu gods Indra and Brahma. Certainly in this relief the parasol bearer may represent Indra because he wears a tall crown. If the object in the right hand of the other figure is a waterpot, then he may represent Brahma. In that case, there may be some justification for identifying the scene as Śākyamuni Buddha's descent from the thirty-third heaven where he had gone to preach to his parents. However, there is no mention in the texts that he rode a bird as he descended; rather, he walked down a ladder. Even more mysterious than the identification is the function of such reliefs: all have a hole in the center as if a dowel had been passed through, a curious element that remains unexplained.

Most reliefs of this subject are rather small, but this example is unusually large. Stylistically too the figures in these reliefs, with their strong faces and disproportionately large hands and feet, reflect a distinct ethnic stamp. It seems closely related to some of the sculptures found in the province of Kalasin in northeast Thailand (cf. Charoenwongsa and Diskul, figs. 51 and 54).

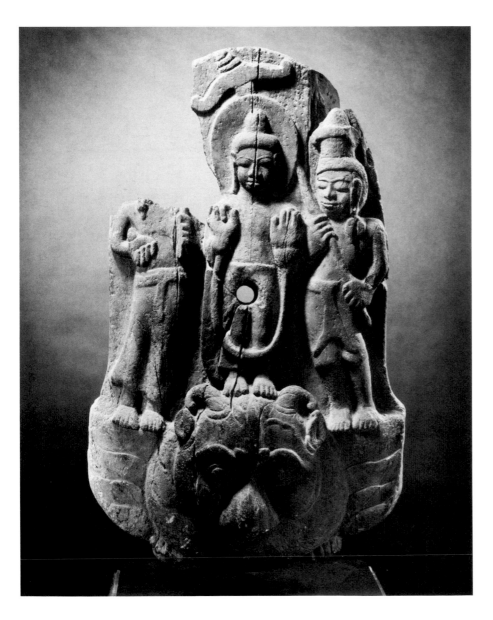

34. A Buddha

Central Java
9th century
Gray volcanic stone
h: 33 in. (83.8 cm.)

A figure dressed in monastic garb
is seated here in the classic
posture of a yogī. His now broken
hands must once have formed the
distinctively Buddhist gesture
that signifies the teaching of the
Law. His upper garment, its
volume indicated by a fold over
the left forearm, drapes his body
tightly, leaving the right arm and
shoulder bare. Very likely, the
figure represents one of the tran-
scendental Buddhas such as Vair-
ochana of the Mahayana
pantheon rather than the histor-
ical Śākyamuni. The image is
basically of the same type that
may be seen both at the Boro-
budur and the Chandi Sewu, two
of the most impressive Buddhist
monuments on the plains of
Prambanam.

These remarkably simplified
Javanese Buddha images depict
the serenity and impassive gran-
deur of an ideal yogī. Were the
figure complete, its head would
form the apex of an equilateral
triangle and one could fully
appreciate the underlying
geometrical perfection of its
design.

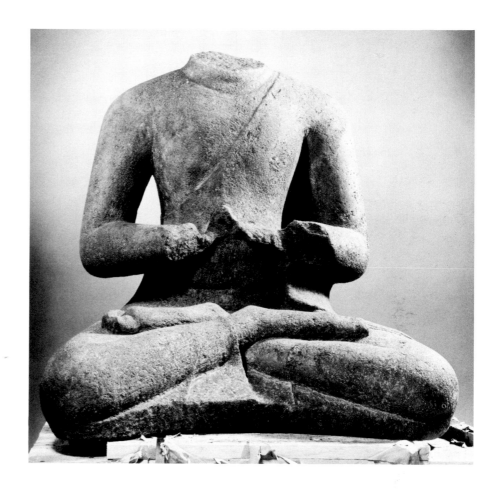

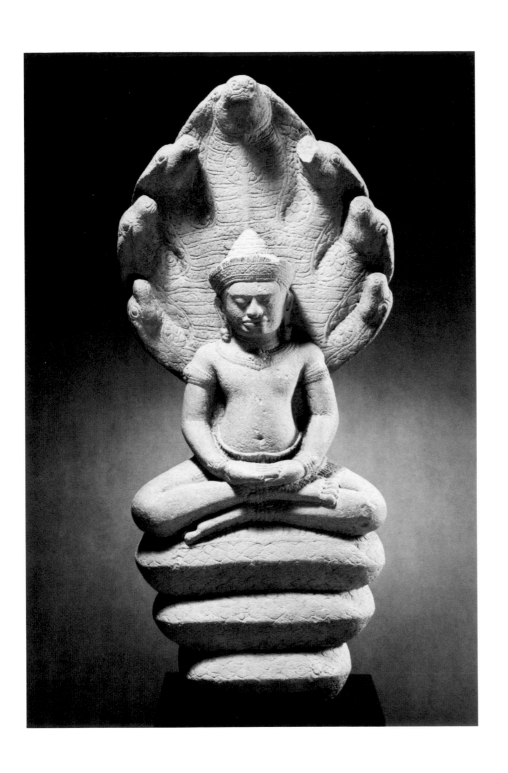

35. Buddha Sheltered by Muchalinda
Cambodia
12th century
Beige sandstone
h: 31¾ in. (80.6 cm.)

A crowned and ornamented Buddha is seated in the meditating posture on the coils of a serpent whose seven hoods form a canopy over the Buddha's head. His hands rest on his lap in the meditating gesture (*dhyānamudrā*) and his eyes are completely closed. This is a hieratic representation of an incident related to the Buddha's enlightenment cycle at Bodh-Gaya. One day, a storm broke out as he sat under the Bodhi tree, and the serpent king Muchalinda spread out his multiple hoods to protect the Master. This theme was especially popular in both Cambodia and Thailand, and frequently in such depictions the transcendental nature of the Buddha is emphasized by providing him with a crown and jewels.

The sculpture is typical of the twelfth-century Cambodian style with its rather squat figural proportions and the Buddha's very square face. Note also how serpentine his legs are, while the lively nāga hoods impart a sense of majestic grandeur to the impassive figure. The sculpture is remarkably well preserved, and the back is equally finished.

36. Buddha Śākyamuni

Thailand, Sukhothai School
14th–15th century
Bronze with green patina
h: 8½ in. (21.6 cm.)

This bronze represents an image type that was extremely popular in Thailand. Buddha Śākyamuni is seated here in meditation and his right hand performs the gesture known as *bhūmisparśa*, symbolizing the occasion of Śākyamuni's enlightenment under the Bodhi tree at Bodh-Gaya. It is believed that Māra, the god of desire, came to tempt the meditating Buddha and, because he was alone, he called upon the earth (*bhūmi*) by touching (*sparśa*) it to witness his victory over Māra. The image type therefore represents the enlightenment of Śākyamuni.

A beautiful bronze of the Sukhothai school, this figure of the Buddha is a classic expression of poised serenity. The long, slim fingers, the inordinate elongation of the earlobes, the narrow eyes, and the pointed flame crowning the head are some of the characteristic features of Buddha images of this period. Less usual, however, is the plain end of the upper garment's fold which is generally seen in figures of the twelfth and thirteenth centuries (see Boisselier and Beurdeley, figs. 77, 81, 83).

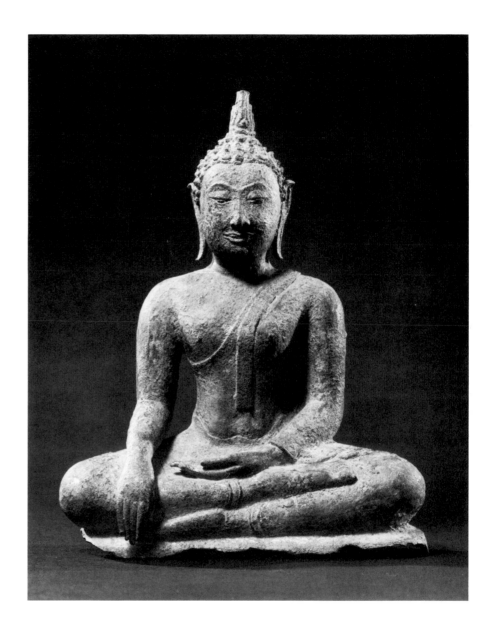

37. Buddha Śākyamuni
 Thailand, Sukhothai School
 14th–15th century
 Gilt bronze
 h: 10¼ in. (26.0 cm.)

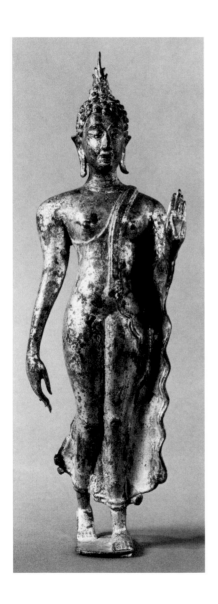

This iconography, in which we see a Buddha actually walking with his right hand stretched gracefully along the body and the left raised in the gesture of reassurance (*abhayamudrā*), is an invention of the Sukhothai school and remained extremely popular in subsequent Thai art. Scholars generally characterize such figures as "Walking Buddhas," a term merely descriptive of the figure's physical activity. It is possible, however, that figures in this posture represent the Buddha descending from the thirty-third heaven after his sermon before his parents. The identification seems plausible because Buddha is shown walking down in exactly this manner in a panel representing the whole scene in a Sukhothai monument (J. Boisselier and J. Beurdeley, fig. 90).

The kingdom of Sukhothai lasted only about two centuries (13th–15th), but it created a new image type for the Buddha that is both iconographically and stylistically different from the earlier Mon-Dvāravatī figures (nos. 32, 33). Obvious differences may be noted in the features of the face and the abstract modeling of the body, which is softer and more linear; in the stylization of the gestures of the hands, with their unnaturally long and delicate fingers; and in the flame that surmounts the *ushnīsha* or the bump on the head. New influences may have arrived at Sukhothai both from Sri-Lanka and Nagapattinam in South India, although the ultimate prototype for the "Walking Buddha" can be traced to Ajanta.

38. Buddha Śākyamuni

Thailand, Ayuthya School
15th–16th century
Beige sandstone
h: 14¾ in. (37.5 cm.)

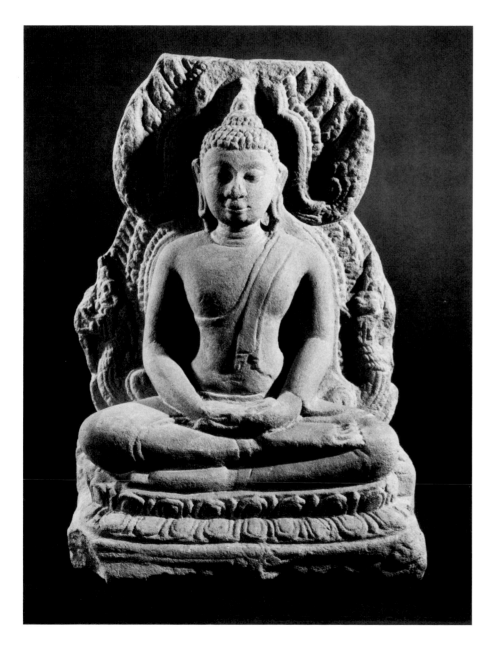

The impassive figure of Buddha Śākyamuni is seated in meditation on a lotus against an elaborately designed throne back. Śākyamuni's hands rest on his lap in the meditating gesture (*dhyāna-mudrā*) and a jewel, symbolizing wisdom, surmounts the bump (*ushnīsha*) on his head. Generally during this period we encounter a flame (see no. 36) rather than a jewel. Two dragons rear their heads on either side of the Buddha, and the swaying forms surrounding the niche around the head appear to be sylized nāgas or serpents. Thus, the sculpture may represent the Buddha-Muchalinda theme (see no. 35).

While this figure of the Buddha is modeled with the same abstraction and elegance as the 1492 Buddha in the Wat Pra Sing Luang at Chieng Mai (see Boisselier and Beurdeley, fig. 114), the decoration of the throne is considered to be a late development at Ayuthya (cf. ibid., fig. 129). The treatment of the Buddha's upper garment (*sanghāti*) is also more characteristic of fifteenth- and sixteenth-century Buddha images than those of the seventeenth century. The *makara* dragons along the sides are comparable to ceramic representations of this motif generally datable to the fourteenth and fifteenth centuries (see ibid., fig. 101).

Jaina Deities

39. A Jaina Stele
Uttar Pradesh, Sarnath Region
6th–7th century
Cream sandstone
h: 20 in. (50.8 cm.)
M.77.49

Considering its antiquity, this busy stele is remarkably well preserved. The strongly symmetrical composition is divided into three sections. Along the bottom, several children are staging a ram fight, while an irate bearded ascetic with his left hand raised seems determined to chase the boys away from their favorite sport. In contrast to this lively scene, two deities are seated hieratically in the middle section of the stele. The female has a child on her lap while another boy clings to the side of her consort. A small image of a meditating Jina is seated atop the tree which forms a canopy over the principal deities. On either side is a flying celestial bearing a garland.

The exact identification of the principal deities is difficult, and they may represent either tutelary gods or the parents of the Jina. The latter identification seems more probable since the seated boy and the Jina above the tree are given identical hair styles. Whatever the identification, the sculpture is a fine example of a Jaina image that reflects a balance between the hieratic needs and the narrative impulse.

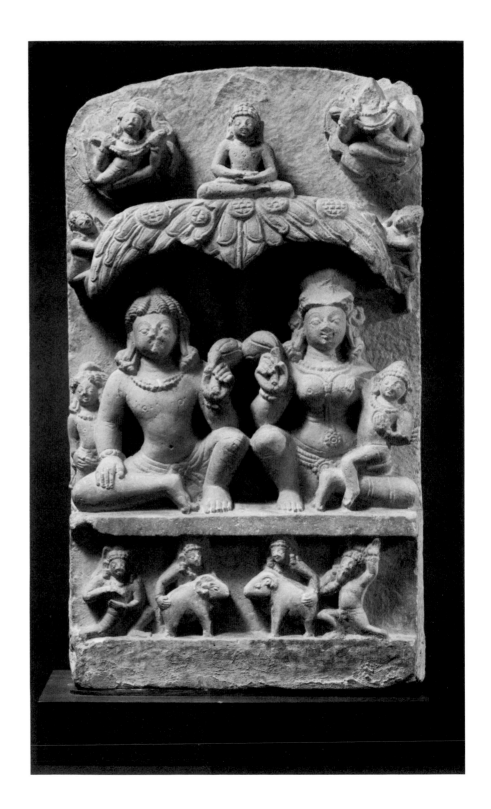

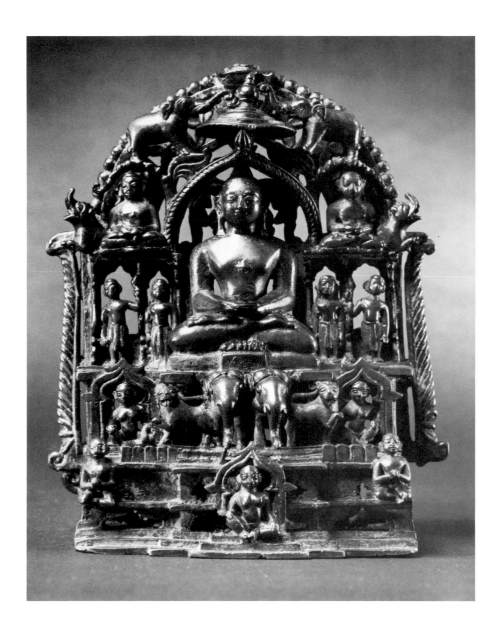

40. Jina Anantanātha
Western India
11th–12th century
Bronze
h: 8¼ in. (21.0 cm.)

The central figure in this intricate shrine can be identified an Anantanātha, the fourteenth of the twenty-four Tīrthaṁkaras or Jinas, who constitute the supreme beings in the Jaina pantheon. He can be identified by the bird (*śyena*) lightly etched on the base of his seat. Two other Tīrthaṁkaras stand on either side and two more are seated at his shoulder height. Since the Jinas are clad, the bronze belongs to the Śvetāmbara sect. Anantanātha's seat is supported by two elephants and two lions, and two more elephants are adoring the Tīrthaṁkara on either side of the umbrella above his head. Several other figures constitute the pantheon, and the two kneeling figures with folded hands probably represent the donors.

Although the use of symmetry dominates the composition, the figures, interestingly, are distributed in several different planes. The severity of the austere Tīrthaṁkaras, seated in the lotus position or standing in the *kāyotsarga* posture, is relieved considerably by the lively animals and the variety of architectural features.

41. A Jaina Shrine

Western India
Dated 1601
Brass
h: 15½ in. (39.4 cm.)

The figures of twenty-four naked Tīrthaṁkaras or Jinas are represented here in a strictly geometric configuration. Because of the nudity of the figures one realizes that this shrine belonged to a devotee of the Digambara sect. There is nothing to distinguish the figures except for the two in the second tier from the top who are protected by serpent hoods. However, the central figure probably represents Mahāvīra, the twenty-fourth Tīrthaṁkara who is the most important of the group. As in the earlier bronze (no.40), here too the throne of the principal figure is supported by lions and elephants, and several other figures (such as flywhisk bearers, *yaksha* and *yakshī* attendants, devotees, and donors) complete the group. Unlike the other bronze, the execution here is more summary and the figures are hard and static. The animals too are not quite as lively, and there is a greater tendency toward abstraction and geometric formalism.

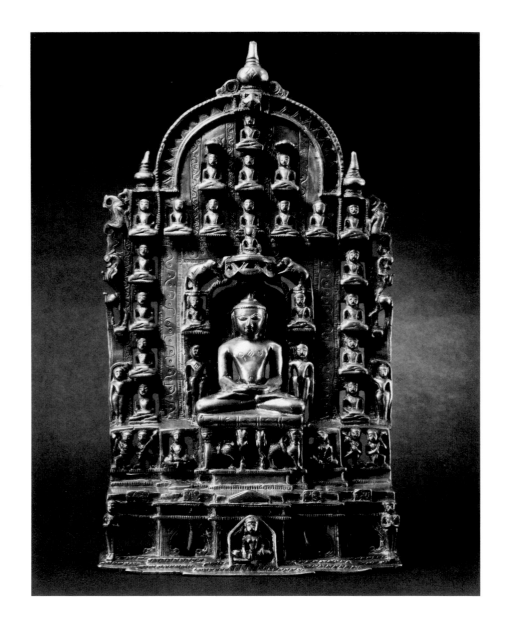

Bibliography

Auboyer, J., *Introduction à l'étude de l'art de l'Inde*, Rome, 1965.

Banerjea, J.N., *The Development of Hindu Iconography*, 2nd ed., Calcutta, 1956.

Bernet Kempers, A.J., *Ancient Indonesian Art*, Amsterdam and Cambridge, Mass., 1957.

Bhattacharyya, B., *Indian Buddhist Iconography*, 2nd ed., Delhi, 1974.

Bhattacharyya, B.C., *The Jaina Iconography*, 2nd ed., Delhi, 1974.

Boisselier, J., *Le Cambodge*, Asie du Sud-est, pt. I, Paris, 1966.

Boisselier, J., and Beurdeley, J., *The Heritage of Thai Sculpture*, New York and Tokyo, 1975.

Coedes, G., *Indianized States of Southeast Asia*, Honolulu, 1968.

Coomaraswamy, A.K., *History of Indian and Indonesian Art*, New York, 1965.

Davidson, J.L., *Art of the Indian Subcontinent from Los Angeles Collections*, Los Angeles, 1968.

Gonda, J., *Viṣṇuism and Śivaism*, London, 1970.

Harle, J.C., *Gupta Sculpture*, Oxford, 1974.

Kramrisch, S., *Indian Sculpture*, Philadelphia, 1960.

Le Bonheur, A., *La sculpture indonesienne au Musée Guimet*, Paris, 1971.

Lee, S.E., *A History of Far Eastern Art*, Englewood Cliffs, New Jersey and New York, 1964.

Lippe, A., de, *The Freer Indian Sculptures*, Washington, D.C., 1970.

Pal, P., "Notes on Two Sculptures of the Gupta Period," *Archives of Asian Art*, XXIV, 1970-71, pp. 76-79.

Pal, P., *The Sacred and Secular in Indian Art*, Santa Barbara, 1974.

Pal, P., *Bronzes of Kashmir*, Graz and New York, 1975.

Pal, P., "South Indian Sculptures in the Museum," *Los Angeles County Museum of Art Bulletin 1976*, XXII, pp. 30-57.

Pal, P., *The Sensuous Immortals*, Los Angeles, 1977.

Rowland, B., *The Arts and Architecture of India*, 3rd ed., Baltimore, Md., 1967.

Trabald, J., *The Art of India*, Northridge, 1975.

Zimmer, H., *Myths and Symbols in Indian Art and Civilization*, New York, 1953.

Zimmer, H., *The Art of Indian Asia*, 2 vols., 2nd ed., New York, 1960.